FEDERICO ZERI (Rome, 1921-1998), eminent art historian and critic, was vice-president of the National Council for Cultural and Environmental Treasures from 1993. Member of the Académie des Beaux-Arts in Paris, he was decorated with the Legion of Honor by the French government. Author of numerous artistic and literary publications; among the most well-known: *Pittura e controriforma*, the Catalogue of Italian Painters in the Metropolitan Museum of New York and the Walters Gallery of Baltimora, and the book *Confesso che ho sbagliato*.

Work edited by FEDERICO ZERI

Text
based on the interviews between
FEDERICO ZERI and MARCO DOLCETTA

This edition is published for North America in 1999 by NDE Publishing*

Chief Editor of 1999 English Language Edition
ELENA MAZOUR (*NDE Publishing**)

English Translation
SUSAN WHITE FOR SCRIPTUM S.R.L.

Realisation
CONFUSIONE S.R.L., ROME

Editing
ISABELLA POMPEI

Desktop Publishing
SIMONA FERRI, KATHARINA GASTERSTADT

ISBN 1-55321-003-4

Illustration references

Alinari archives: 6t, 22t, 23t-b, 24b, 27l-r, 29, 30b, 31, 36b, 40b, 43t-br, 44/VI-VII-X-XII, 45/II-III-X-XII.

Bridgeman/Alinari archives: 24t, 32.

Giraudon/Alinari archives: 22b, 28l, 42 , 44/XI, 45/V-VII-IX.

Luisa Ricciarini Agency: 2, 15bl-br, 16, 25, 28r, 33, 36t, 40t, 44/IV-VIII, 45/VI.

Photographic archive of Musei Vaticani: 1, 2-3, 4-5, 6b, 6-7, 8, 9, 10, 11, 12, 13, 14, 18, 19tr-bl, 45/I.

Photographic archive of Musei Vaticani/Photo G. Vasari: 4b.

RCS Libri Archives: 4t, 15t, 17, 19br, 20c-b, 20-21, 21b, 26-27, 34, 35t-b, 37, 39t-b 42b, 44/I-III-V-IX, 45/VI-VIII-XI-XIII-XIV

R.D.: 19tl, 20t, 21t, 26, 30t, 38t-b, 38-39, 40-41, 41t-b-c, 43bl, 44/II.

Printed and bound by Poligrafici Calderara S.p.A., Bologna, Italy

* a registred business style of NDE Canada Corp.
18-30 Wertheim Court, Richmond Hill, Ontario
L4B 1B9 Canada, tel. (905) 731-12 88

The captions of the paintings contained in this volume include, beyond just the title of the work, the dating and location. In the cases where this data is missing, we are dealing with works of uncertain dating, or whose current whereabouts are not known. The titles of the works of the artist to whom this volume is dedicated are in blue and those of other artists are in red.

RAPHAEL
SCHOOL OF ATHENS

The SCHOOL OF ATHENS is the undisputed master-piece of rational Renaissance perspective. The cornerstone of the decoration in the apartments of Pope Julius II in the northern wing of the Vatican Palace, it is the most mature work by Raphael, the painter whom Vasari described as

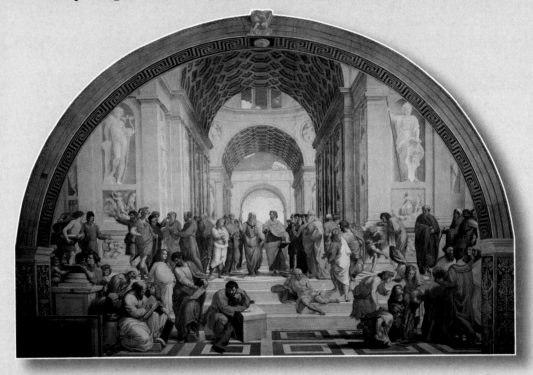

a "mortal god." The fresco has survived intact for over four centuries, due to the superb quality of the plaster and the colors, and represents the temple of Greek philosophy. At the dawn of the Cinquecento, when humanistic creativity was at its height, Raphael portrayed man's return to the center of the universe.

THE TEMPLE OF PHILOSOPHY

SCHOOL OF ATHENS

1509-1511

● Stanza della Segnatura, Vatican, Rome
(fresco, base 770 cm)

● The *School of Athens* is part of the wall decoration in the Stanza della Segnatura, in the apartments of Pope Julius II, in the world Giuliano della Rovere. Raphael was just twenty-five when, in the autumn of 1508, he was summoned by the Pope to decorate his new apartments. The rooms had previously been frescoed by Piero della Francesca, a Tuscan painter known for his rigorous perspective and almost abstract perfection of volumes. These decorations, pervaded by a subtle luminosity, fascinated the young Raphael who, as Giorgio Vasari tells us, suffered a great deal when he had to destroy them. He had copies made, which are now lost.

● In his *Lives of the Artists* Vasari also testifies that the *School of Athens* in the Stanza della Segnatura was the first work executed by the young painter, who later painted the frescoes on the other walls, i.e., the *Disputation Concerning the Blessed Sacrament*, *Parnassus* and *Justice*.

● When humanistic creativity was at its height, the papal court experienced another period of great splendor, marked by intense intellectual and spiritual expression. In paying tribute to the world of Greek philosophy, the *School of Athens* represents the new authoritative feeling of independence experienced by man, who is once again at the center of the universe, and complete master of the intellect and spirit.

● In a magnificent architectural setting and hierarchical intellectual world, Raphael gathers together the sages of Greek philosophy, grouped according to the various disciplines: mathematics, physics and metaphysics on one side; grammarians, rhetoricians and logicians, on the other.

◆ FILIPPO LEONARDI
Raphael teaches perspective to Fra Bartolomeo della Porta.
Raphael was the mentor of many artists of his time.

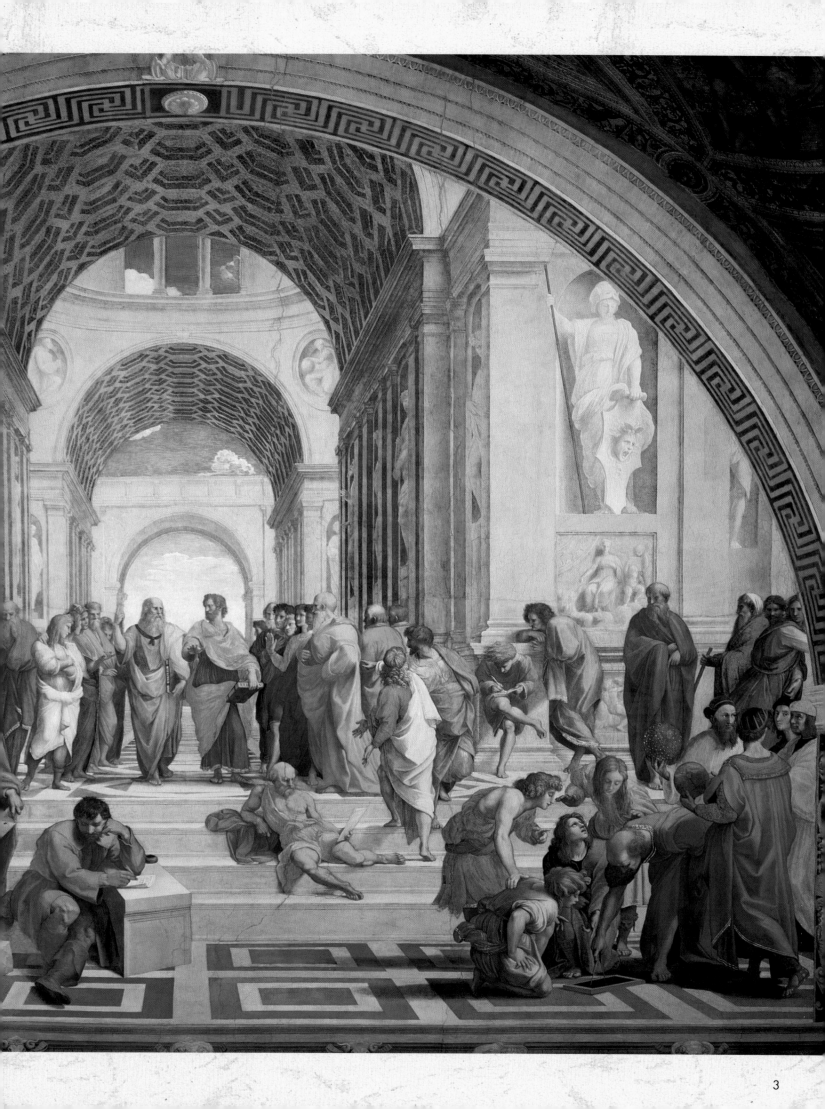

IN FRONT OF THE MASTERPIECE

THE POPE'S LIBRARY

After being elected Pope in November 1503, Julius II moved to the upper floor of the northern wing in the Vatican Palace, which was built around the mid-fifteenth century by Pope Nicholas III. ● Once he had chosen his rooms, Pope Julius entrusted the decoration to Raphael Sanzio of Urbino, a great young talent recommended by the extremely powerful Bramante who was chief supervisor of all the papal buildings under construction at that time.

● The Stanza della Segnatura was used by Julius the II as a library. The bookcases were located beneath the large frescoes, where today there is a painted wainscot that was executed later, when the book shelves were eliminated by Julius II's successor, Pope Leo X. The layout of the library was perfectly rational: the pictorial subjects of the frescoes on the walls corresponded to the categories of books on the shelves below. Thus the *Disputation Concerning the Blessed Sacrament* was located above the books on theology, the *School of Athens* above those on philosophy, the *Parnassus* in the lunette above the books of poetry, and the two scenes with *Pope Gregory IX approving the Decretals* and *Justinian with the Pandects* on the wall where the legal texts were housed.

● The complex structure of the walls was reflected in the frescoes on the ceiling and in the small vaulting cells, with symbolic representations of *Justice*, *Poetry*, *Philosophy* and *Theology* on the medallions and allegorical representations of the *Judgment of Solomon*, the *Temptation of Adam and Eve* and *Apollo and Marsyas* in the four rectangular scenes. According to the Renaissance concept of a universal order that was possible under the Church of Rome, philosophy and theology were the foundations of the sage's wisdom and Christian revelation, poetry was the highest of the superior powers of the spirit, and justice represented the apex of the moral hierarchy.

◆ POPE JULIUS II
(1512, Florence, Uffizi)
After being elected Pope in November 1503, Julius II refused to live in the apartments occupied by his predecessor and bitter enemy Alexander VI Borgia, and moved to the upper floor.

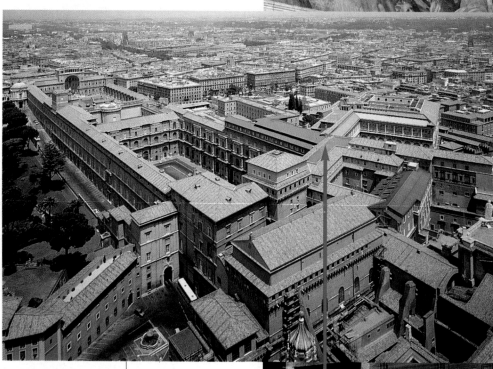

◆ VIEW
OF THE VATICAN
The arrow indicates the rooms of Julius II, in the north wing of the Vatican Palace that was built around the mid-fifteenth century by Pope Nicholas III. The Stanza della Segnatura was initially the seat of the Tribunale della Segnatura from which it takes its name.

THE APARTMENTS OF JULIUS II

4

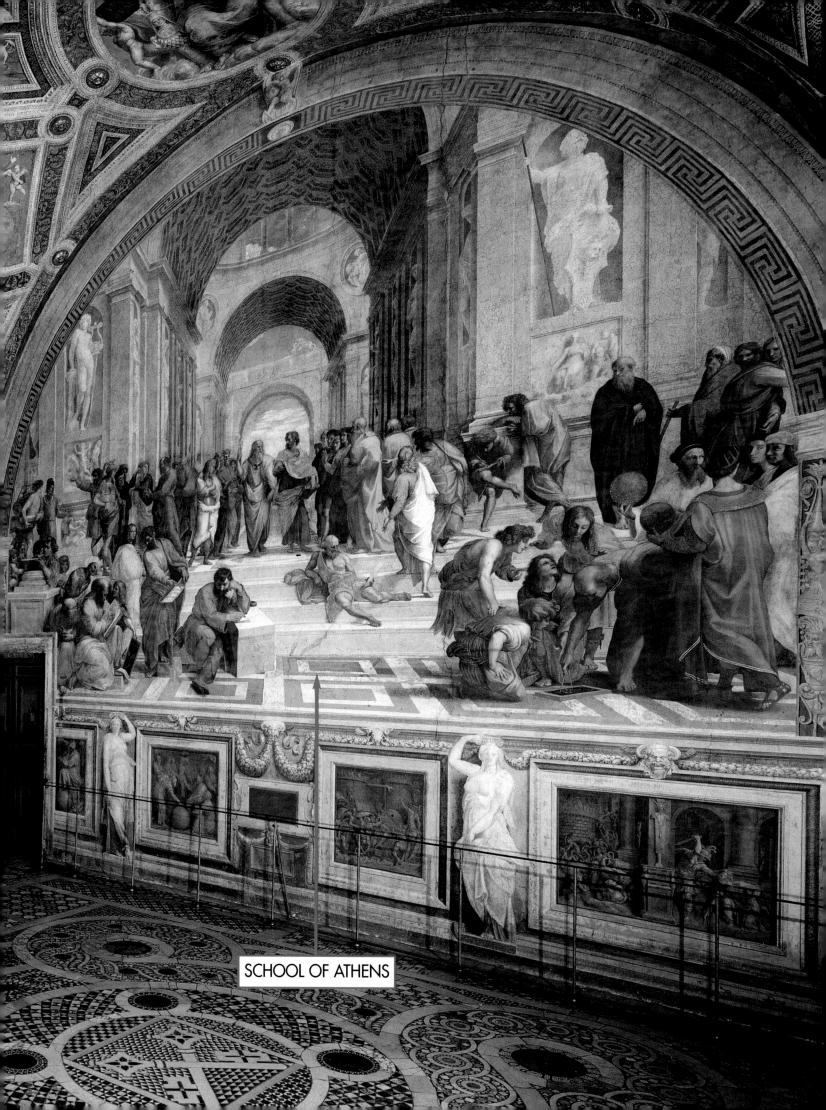

SCHOOL OF ATHENS

A MEETING OF LEARNED MEN AND ARTISTS

The *School of Athens* is set in a magnificent building in perfect perspective, which mirrors Bramante's project for the Basilica of St Peter. According to Vasari, Bramante himself designed this part of the fresco.

● Two large statues in niches dominate the rich array of characters. Apollo, on the left, and Minerva, on the right, strongly symbolize Reason and Morality, which dominate Passion. In his left hand Plato is holding the *Timaeus* while his right hand is pointing upwards, towards the empyrean, the world of ideas that, according to the Christian Neoplatonist ideals spread by Marsilio Ficino, was the only possible reality. Next to him Aristotle stretches out his open right hand between heaven and earth, and carries the *Ethics* in his left.

● Starting from the extreme left, we see Epicurus, crowned with vine leaves, holding a discourse on hedonism. Lower down, to the right, there is the group with Pythagorus who is writing in a large tome, surrounded by his pupils. Behind him, wearing a turban, is Averroës, Aristotle's Arab commentator. The youth dressed in white behind the group is Francesco Maria della Rovere, Duke of Urbino, who would later fight for the papal army and be defeated during the Sack of Rome in 1527, in which he played a leading role. Behind, in profile, Socrates is disputing with Alcibiades, the young man wearing armor. Sitting on the steps, in the foreground, is Heraclitus, the philosopher from Ephesus, in the guise of Michelangelo, leaning against a block of marble, and the Cynic philosopher Diogenes. In the group on the right, Euclid, who has the face of Bramante, is bending over a slate as he demonstrates, with a pair of compasses, a theorem to his pupils. Standing behind him, Zoroaster holds the celestial globe, while Ptolemy, seen from behind, holds the terrestrial one. Lastly, Raphael appears in a self-portrait, with a black cap, beside fellow artist Giovanni Antonio Bazzi, called Sodoma, who is wearing a white cap. Thus he is immortalized as he contemplates the spiritual universe of the Renaissance.

● The fresco is dated and signed by the young painter in gold characters on the neckband of Euclid's robe.

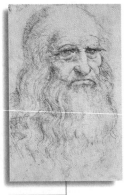

◆ LEONARDO DA VINCI
Self portrait
(1515, Turin, Biblioteca Reale)
In the *School of Athens*, Plato has the face of Leonardo.

◆ THE LEARNED GATHERING
Plato and Aristotle preside over the learned gathering as exponents of idealism and realism, the two major schools of classical thought.
In his left hand Plato is holding the *Timaeus* while his right hand is pointing upwards, indicating the world of ideas. Aristotle stretches out his open right hand between heaven and earth, and carries the *Ethics* in his left.

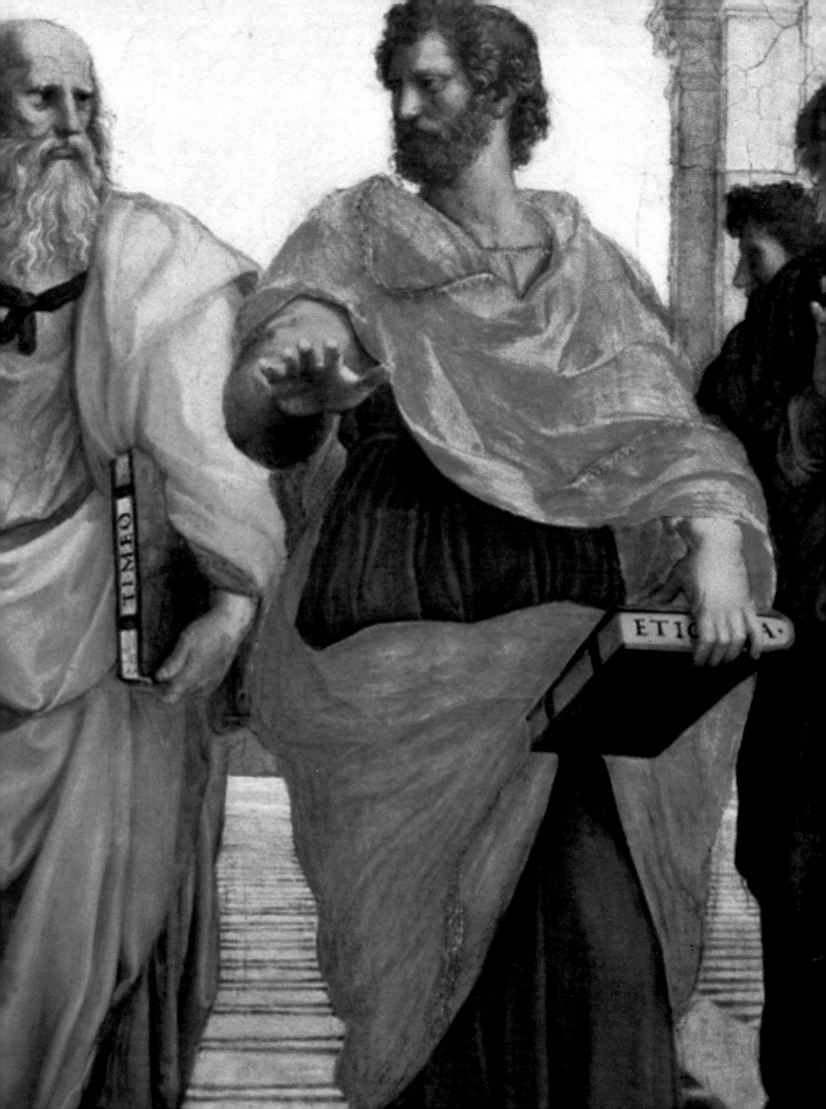

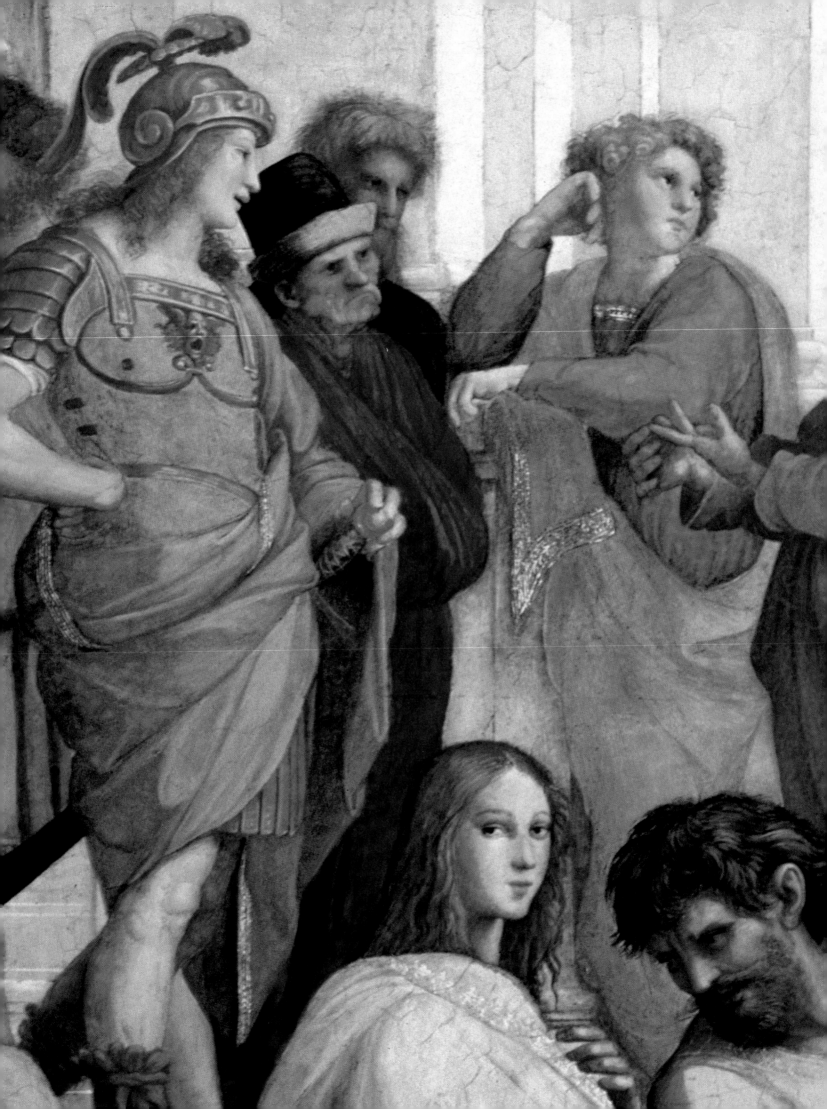

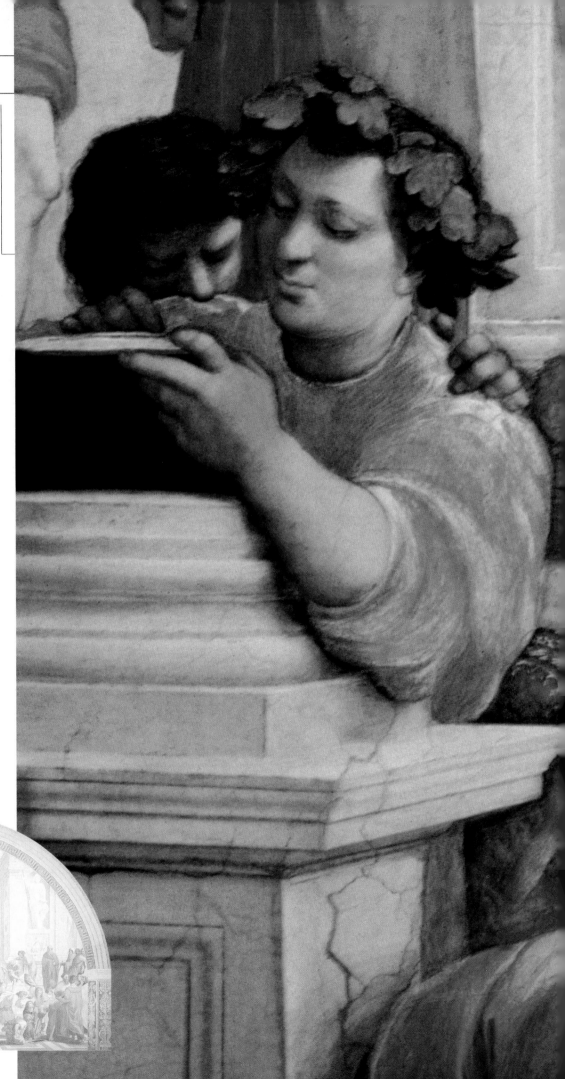

◆ EPICURUS,
THE HEDONISTIC
PHILOSOPHER
Raphael immortalizes
Epicurus,
the philosopher
born in Samos in 341
BC, while, crowned
with vine leaves,
he discourses
on hedonism.
The materialist thinker
taught that pleasure
contains the essence
of life. Men and
women, slaves and
Athenian notables,
beautiful haeterae and
young disciples
attended his meetings
in ancient Greece.

◆ SOCRATES
AND FRANCESCO
MARIA DELLA ROVERE
On the steps, in profile,
Socrates is disputing
with a youth wearing
armor, named
Alcibiades. The figure
dressed in white, below,
is the Duke of Urbino,
Francesco Maria della
Rovere, who was
defeated by the
Lansquenets during the
Sack of Rome in 1527.
A good-hearted, ironical,
intelligent and
determined man who
fought for his ideals,
Socrates was much
respected by
Renaissance thinkers.

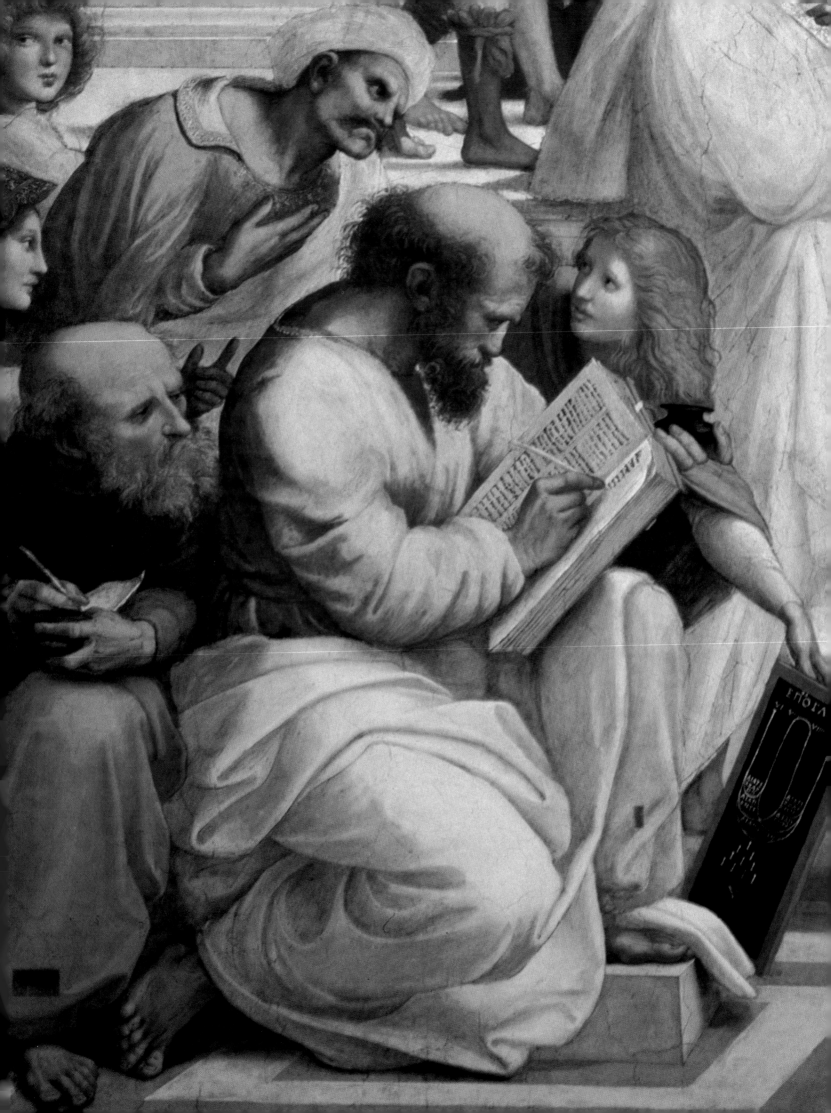

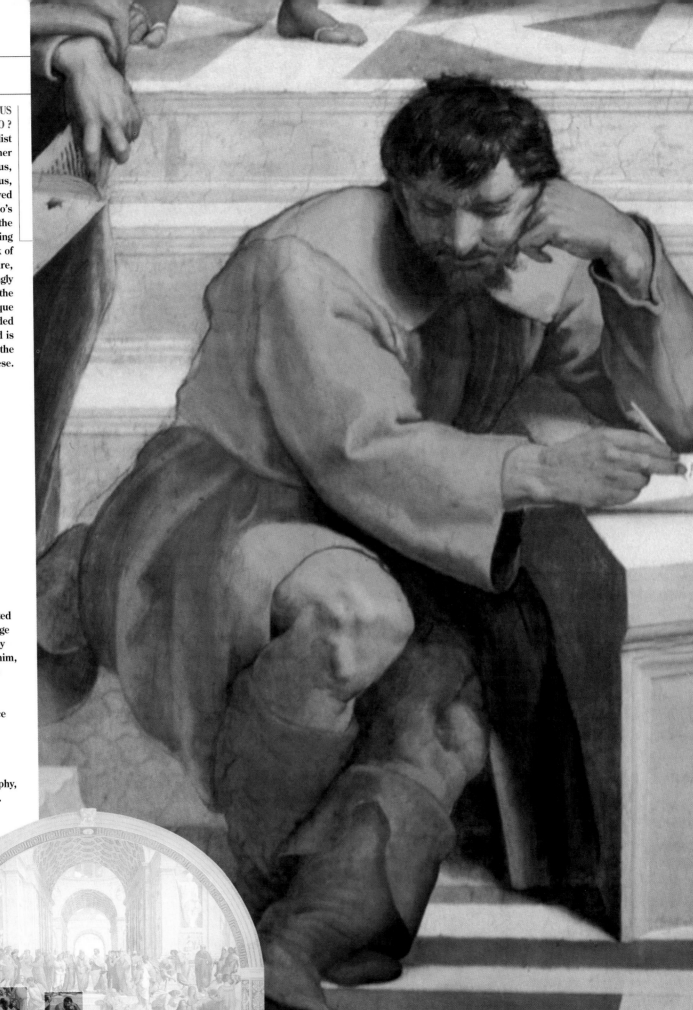

◆ HERACLITUS
OR MICHELANGELO ?
The materialist
philosopher
from Ephesus,
Heraclitus,
is portrayed
with Michelangelo's
face, sitting on the
steps and leaning
against a block of
stone. The figure,
which strongly
embodies the
Michelangelesque
style, was added
later, and is
a tribute to the
master from Caprese.

◆ PYTHAGORAS
AND AVEROËS
The mathematician
Pythagoras is depicted
as he writes in a large
tome, surrounded by
his pupils. Behind him,
wearing a turban, is
Aristotele's Arab
commentator.
Pythagoras' presence
has a powerful
symbolic value:
mathematics
is necessary to
understand philosophy,
to attain knowledge.

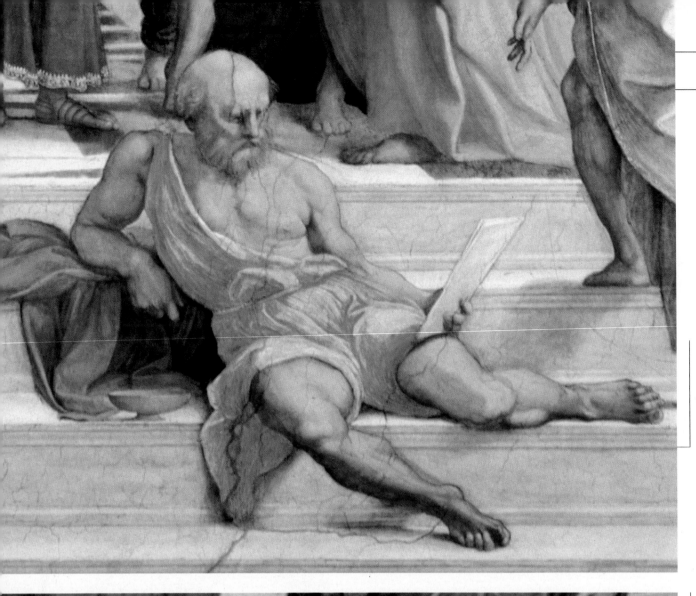

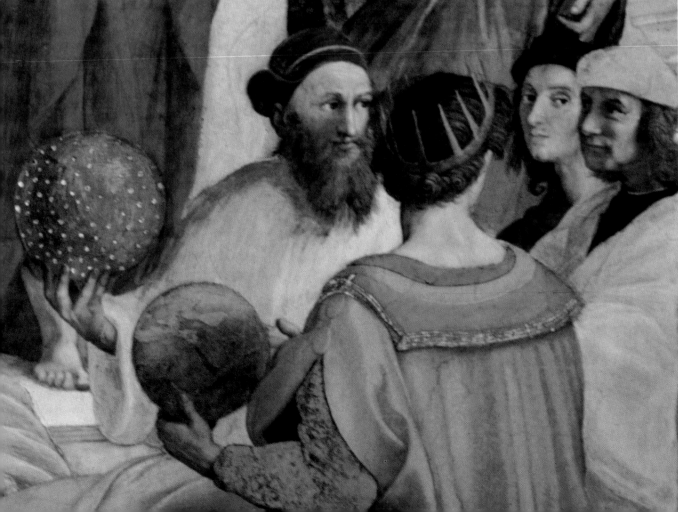

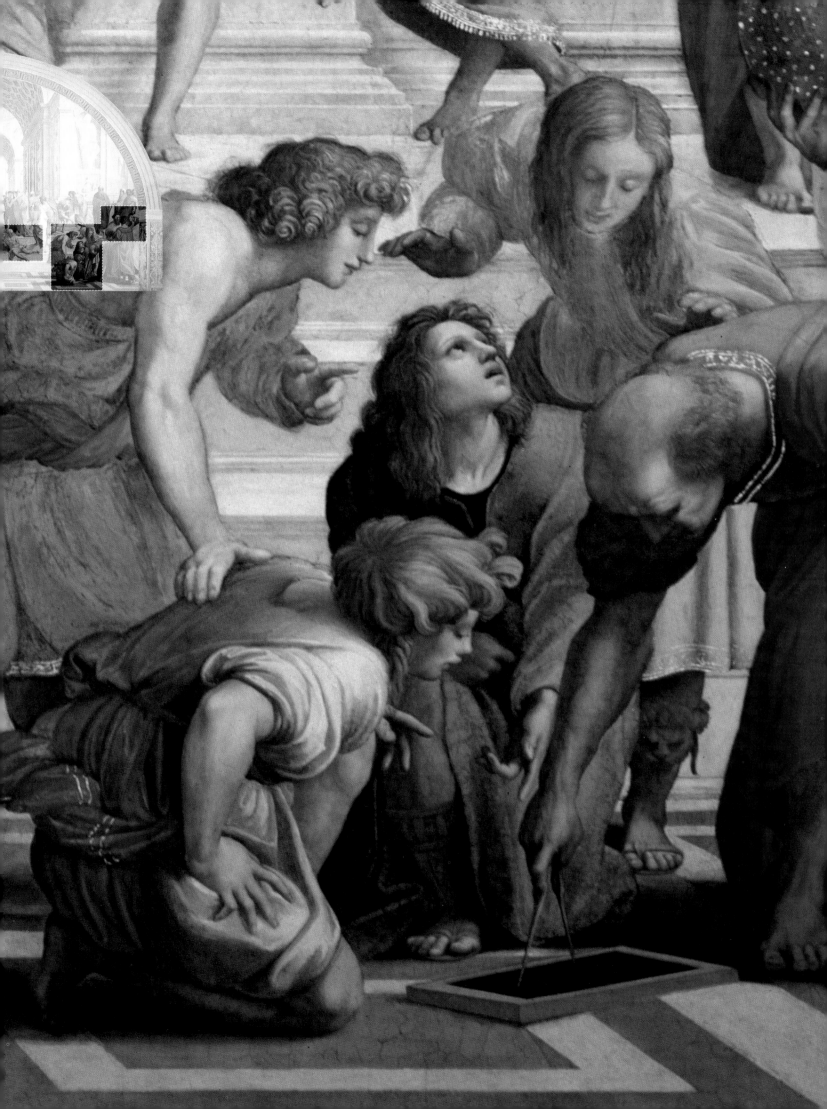

THE ARCHITECTURAL BACKGROUND

Raphael began painting the Stanza della Segnatura at the end of 1508, after being called to Rome in November of that year. The painter indicated the date that work was finished, 1511, on two sides of a window frame. Before him, in 1507, Pope Julius II had called Perugino who was Raphael's first teacher, and Sodoma, with whom he now found himself collaborating.

● The fresco is composed in a rational way: the Great Hall of the *School of Athens* is open on all sides, supported by pilasters, and culminates in a cupola that is made to disappear from view by the perspective. The imposing space in which the learned gathering is taking place—designed, according to Vasari, by Bramante—shows a flair for architectural design, which Raphael was soon to exploit with success. Masaccio, in his fresco of *The Trinity* in Santa Maria Novella in Florence, and Piero della Francesca, in the *Madonna and Child with Saints* in Brera, had already created architectural backgrounds for their paintings with consummate artistry.

● In the *School of Athens* the parabolic line of the round arch of the temple ceiling is intersected by the vanishing point which, starting from the steps, disappears in the sky behind Plato and Aristotle. The two philosophers are standing at the top of the steps, within the parallel lines, at the foot of the large pilasters. Two other groups of figures (all beneath stone images of their false gods) are each gathered around a slate on which a theorem is being demonstrated. The magnificence of the architecture derives from mathematical principles. Hence the steps acquire a strong symbolic value: they define the levels of mathematical training necessary to understand philosophy, to attain knowledge.

● In the original cartoon for the fresco, there was free access to the steps and they were not encumbered by the block of stone against which Heraclitus/Michelangelo is leaning. This new figure, which strongly embodies the Michelangelesque style, was added by Raphael as a tribute to the master from Caprese, who during those same years was working on the cycle of frescoes in the Sistine Chapel.

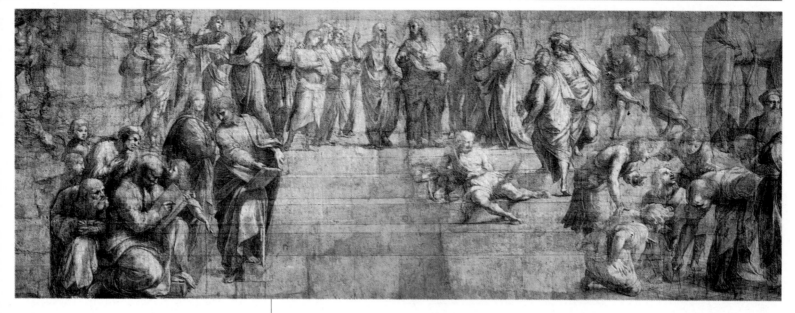

♦ MASACCIO
The Trinity
(1426, Florence, Santa Maria Novella)
The fresco creates the illusion of a deep niche in the wall.

At the base of the pyramidal composition are the two kneeling clients, then the Holy Virgin and St John, followed by Christ, and God at the apex.

♦ THE PREPARATORY CARTOON
The Pinactoteca Ambrosiana in Milan holds the cartoon of the *School of Athens* which reveals that Raphael

made several changes while painting the fresco; for example, the figure of Heraclitus/Michelangelo does not appear in the cartoon.

♦ PIERO DELLA FRANCESCA
Madonna and Child with Saints
(1472, Milan, Pinacoteca di Brera)
The master clearly

defines the geometric rules on which perspective is founded, applying them rigorously to the architectural composition.

THE IDEAL PAINTER

The greatness of Raphael's painting was instantly recognized by his contemporaries, and his fame spread as soon as he arrived in Rome in 1508. Despite this, we actually know very little about his character and his life. Apart from the short biographies by Paolo Giovio and Simone Fornari, the first to provide us with information about Raphael is Giorgio Vasari in his *Lives of the Artists* published in 1550, but thirty years had already passed since the young painter's death.

● Raphael Sanzio was born in Urbino on Good Friday, 6 April 1483, and died prematurely at thirty-seven on Good Friday in 1520. This coincidence, added to the fact that his life and works were considered exemplary by his contemporaries, fueled the myth that surrounded him. The young artist was compared to Christ; his works to miracles. Giovanni Paolo Lomazzo, a Lombard painter and author of treatises, wrote that Raphael's face had a sublime and noble quality "similar to that which all the most illustrious painters represent in Our Lord." Although Vasari preferred Michelangelo, he considered Raphael divine: "One can claim without fear of contradiction that artists as outstandingly gifted as Raphael are not simply men but, if it be allowed to say so, mortal gods" (trans. George Bull). Pico della Mirandola, in a letter written on Easter Saturday in 1520 to announce the death of the young painter to the Duchess of Mantova, said that at the moment of Raphael's demise the skies darkened and manifested the same signs that appeared when Christ died on the cross. He added that profound cracks had opened in the Vatican buildings, which were in danger of falling down, and the terrified Pope had taken refuge in his rooms.

● People even went as far as claiming that Raphael died at thirty-three, like Christ, even though he was actually thirty-seven. Such was the power of his art: the serenity, harmony and beauty of Raphael's paintings, of his Madonnas, was a mystery to his fellow artists, and we still finding their formal and spiritual values difficult to interpret today.

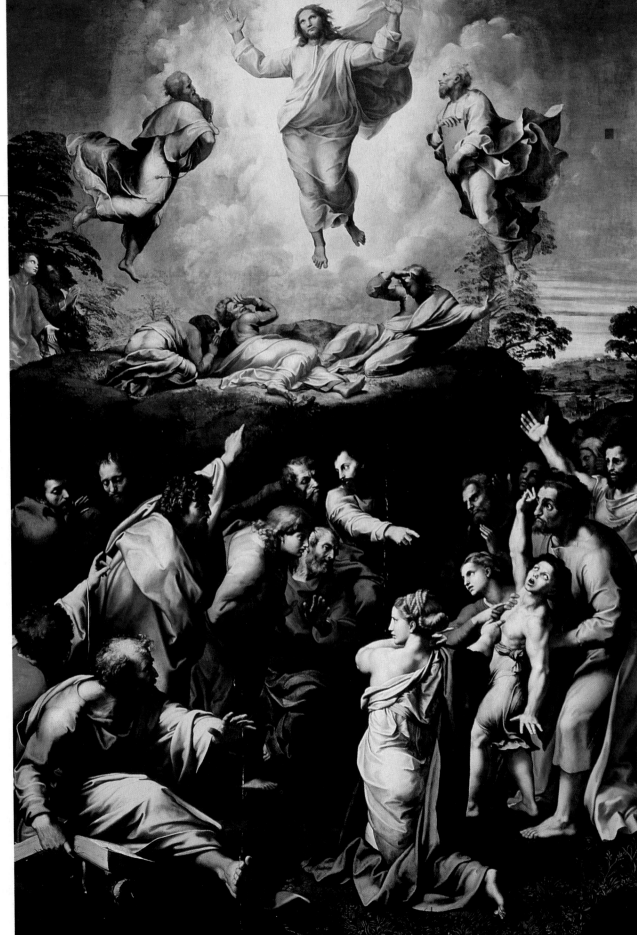

♦ TRANSFIGURATION
(1518, Rome, Pinacoteca Vaticana) Vasari relates in his *Lives* that the *Transfiguration* was hanging above Raphael's bed when died. "As he lay dead in the hall where he had been working they placed at his head the picture of the Transfiguration which he had done for Cardinal de' Medici; and the sight of this living work of art along with his dead body made the hearts of everyone who saw it burst with sorrow." (trans. George Bull). After the young painter's death, the canvas was hung above the high altar of San Pietro in Montorio, in Rome.

♦ SELF-PORTRAIT
(1506, Florence, Uffizi) The young Raphael, a pupil of Perugino, portrayed himself in three-quarter view, with a serene and noble expression. His life and works were held to be exemplary, indeed perfect, which generated the Christological myth that his fellow artists wove around him.

NARRATING WITH COLOUR

In the *School of Athens* Raphael places the characters freely in the setting, creating an effect of great movement. Each group is independent, freestanding, and is distinguished by its own range of colors. Color was of the utmost importance to the master, in fact, especially in such a complex fresco. He worked on one group at a time, making the most important figures stand out by exploiting the optical illusion whereby the warmer tones of red, yellow and orange, appear closer to the viewer. Thus, we see Plato, wearing a purple tunic beneath a scarlet robe, coming towards us; Euclid, although bending down, is illuminated by his gold and vermilion tunic; Pythagoras, seen in profile, and surrounded by pupils, is lit by a powerful beam of light. The luminous effect actually springs from these dynamic tints. Whereas the cold colors like green, blue and violet, which are less luminous, make other compositional elements seem further away from the viewer through the clever illusion of perspective.

● The pictorial technique of the fresco consists in the use of mineral colors applied to the still wet plaster, so that they amalgamate with the base as they dry, and are able to resist time and atmospheric agents. For this reason, the color must be swiftly applied and each section completed separately, according to finely-detailed preparatory drawings.

● A large cartoon of the *School of Athens*, held by the Pinacoteca Ambrosiana in Milan, shows us how Raphael modified the original project as he worked. There was no figure of Heraclitus/Michelangelo, leaning against a block of marble, in the preparatory drawing. It was added as a tribute to Michelangelo whom Raphael greatly admired.

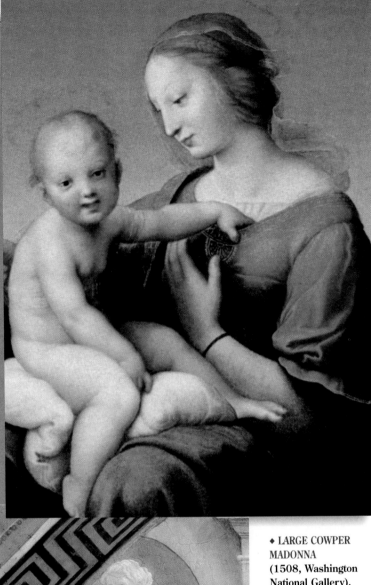

♦ PORTRAIT OF CARDINALE BIBBIENA (1511-12, Madrid, Prado) The red mantle of the Cardinal and the orange robe worn by the figure in the *School of Athens* are painted in warm colors that bring the figures towards the viewer. In the painting of the Cardinal, in particular, the natural elegance of the pose, the skillfully-rendered composition, and the intense colors emphasize his refined spirituality.

♦ LARGE COWPER MADONNA (1508, Washington National Gallery). This oil on wood, formerly part of the Niccolini collection in Florence and which entered the Cowper collection in 1780, is painted in cold hues. The blue of the robe and the pale whitish tone of the flesh of the Madonna and the Child are reminiscent of the marmoreal whiteness of the sculptures in the niches in the *School of Athens* fresco (opposite). The letters MD VII/R.V. PIN, accompanied by Raphael's signature and the date, are visible on the neckline of the Virgin's dress.

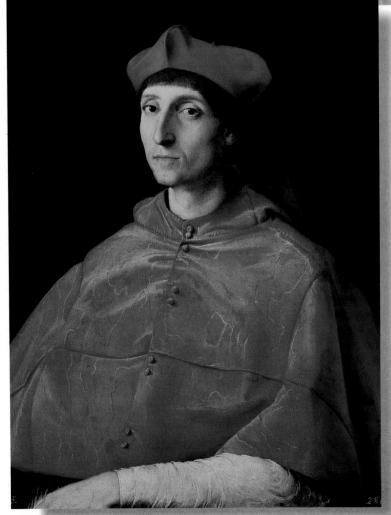

THE PRODIGY

Raphael was the son of an artist; in fact, his father, Giovanni di Sante di Pietro, was a fair to middling painter who modeled himself on Piero della Francesca and Melozzo da Forlì. It was his father, who died prematurely when Raphael was just eleven, who took him to Perugino prior to 1491. Pietro Vanucci, known as Perugino, had a large workshop and was firmly-established in the art world and with its patrons. Thus, Raphael found himself in contact with important clients and commissions when he was still only a boy.

● His remarkable capacity for assimilation permitted him to acquire from his Umbrian master the sense of spatiality that Perugino, in his turn, had learned from Piero della Francesca; and to appropriate the limpid plasticity of Andrea del Verrocchio's sculpted figures. He also adopted Perugino's perfect central perspective and formal harmony. In actual fact, the maturity and beauty of Raphael's early works are so astonishing that they bear little evidence of his training with Perugino. He must have made very swift progress and been extremely productive at the beginning of his career, since the works he created were based on the principles of absolute symmetry adopted by the Pollaiuolo brothers from Florence and also reflected the tranquillity of the landscapes painted by Giovanni Bellini from Venice.

● Raphael adopted the manner of Perugino when the master changed his style and, attenuating the solidity and harmony of his compositions, moved towards absolute formality.

● The *Mond Crucifixion* mirrors the gentleness of Perugino but contains solutions never reached by the Umbrian painter, which make it a masterpiece.

● Even when he worked with Pinturicchio, who took Raphael to Siena with him to fresco the Libreria Piccolomini del Duomo, he far outshone the pictorial manner of the no longer young master. The preparatory drawings for the frescoes in the library, executed by Raphael, are more mature and modern than the fresco itself painted by Pinturicchio.

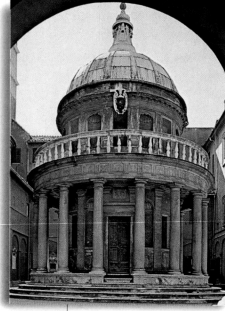

◆ **DONATO BRAMANTE**
Tempietto of San Pietro in Montorio
**(1502, Rome).
It is most probably the source of inspiration for the background of the** *Betrothal of the Virgin.*

◆ **CORONATION OF ST NICHOLAS OF TOLENTINO (1500, Brescia, Pinacoteca Tosio Martinengo, fragment).**

◆ **THE BACKGROUND
The architecture in the background of the** *Betrothal of the Holy Virgin* **recalls the Roman work by Bramante.**

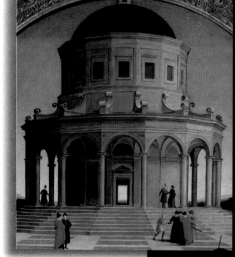

◆ PIETRO PERUGINO
AND BARTOLOMEO
DELLA GATTA
Donation of the Keys
(1484, Rome,
Vatican,
Sistine Chapel)
Raphael's master
had also executed
a papal commission.

◆ BETROTHAL
OF THE HOLY VIRGIN
(1504, Milan,
Pinacoteca di Brera).
One of Raphael's most
mature early works.

◆ MOND CRUCIFIXION
(1503, London,
National Gallery)
In this painting
Raphael achieved
the grace of Perugino,
when the master
himself was going
into a decline.

GENTLEMEN, LOVERS AND POPES

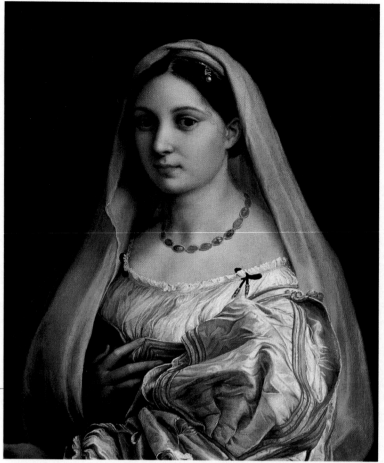

P rior to leaving for Rome in 1508, Raphael had never received the commissions for public works to which he aspired to make a name for himself in Florence, the city of Michelangelo and Leonardo, and had only executed works for private patrons. These were mainly religious works and portraits. His early patrons included Agnolo Doni and his wife Maddalena, two of the leading figures in Florentine society, whom Raphael portrayed according to Flemish models. Perugino-style motifs in the figure of the man and a new Michelangelesque influence in the volumes of the woman's body, are combined with a detailed reproduction of the rich attire and jewelry that symbolized the opulence of a complaisant bourgeoisie.

◆ PORTRAIT OF A WOMAN (LA VELATA) (1516, Florence, Palazzo Pitti) Raphael's portraits of women have always given rise to fanciful conjecture concerning the ladies he loved.

● In Rome, Raphael worked on the *Portrait of Julius II*, for the Church of Santa Maria del Popolo. His contemporaries thought the painting "terrible"—as terrible in fact as the sitter's character! Next he portrayed *Pope Leo X with cardinals Giulio de' Medici and Luigi de' Rossi*, a painting destined to take the Pope's place at a family banquet. The rich color and bold play of chiaroscuro in these two paintings, reveal Raphael's affinity with the Venetian School and the emphasis placed on color.

● When he painted his beloved, probably Margherita Luti from Siena, the daughter of a baker in the Santa Dorotea quarter in Rome, Raphael abandons himself to extremely luminous tones expressing human warmth. The gold, cream and white of her gown and her pale rosy skin, light up the image of the young woman immortalized in the *Portrait of a Lady* (*La Velata*) in Palazzo Pitti and in the *Fornarina* in the Borghese Gallery.

● The composition of the *Portrait of Baldassarre Castiglione* is unusual in that the subject is depicted from the waist up and his torso and arms are slightly turned to one side. Raphael endows his illustrious friend with a magnetic gaze, which establishes direct contact with the viewer, and adorns his clothing with thick, soft velvet of a remarkably intense color.

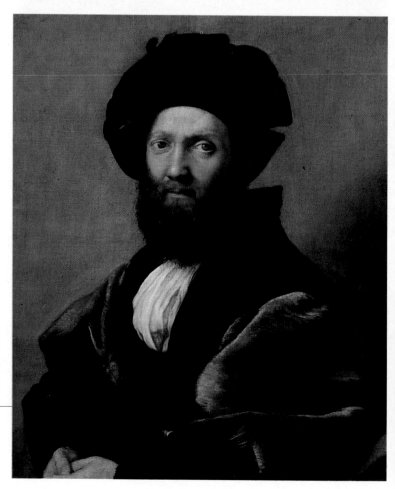

◆ PORTRAIT OF BALDASSARRE CASTIGLIONE (1515, Paris, Louvre) In this famous painting of his cultured friend, Raphael anticipates Caravaggio's early works in an extraordinary way.

◆ PORTRAIT
OF MADDALENA DONI
(1506-07, Florence,
Palazzo Pitti)
Although the reference
to Leonardo
da Vinci's painting
is clear, Raphael's
woman
is completely
devoid of mystery.

◆ POPE LEO X
WITH CARDINALS
GIULIO DE' MEDICI
AND LUIGI DE' ROSSI
(1518-19,
Florence, Uffizi)
Leo X de' Medici
was the successor
of Julius II.
His papacy lasted from
1513 to 1521.
The figures appear
firmly fixed
in the pictorial
composition.
The light and colors
are reminiscent
of Venetian painting,
so much so that
Bernini described
the portrait as
"a Raphael in the
manner of Titian."

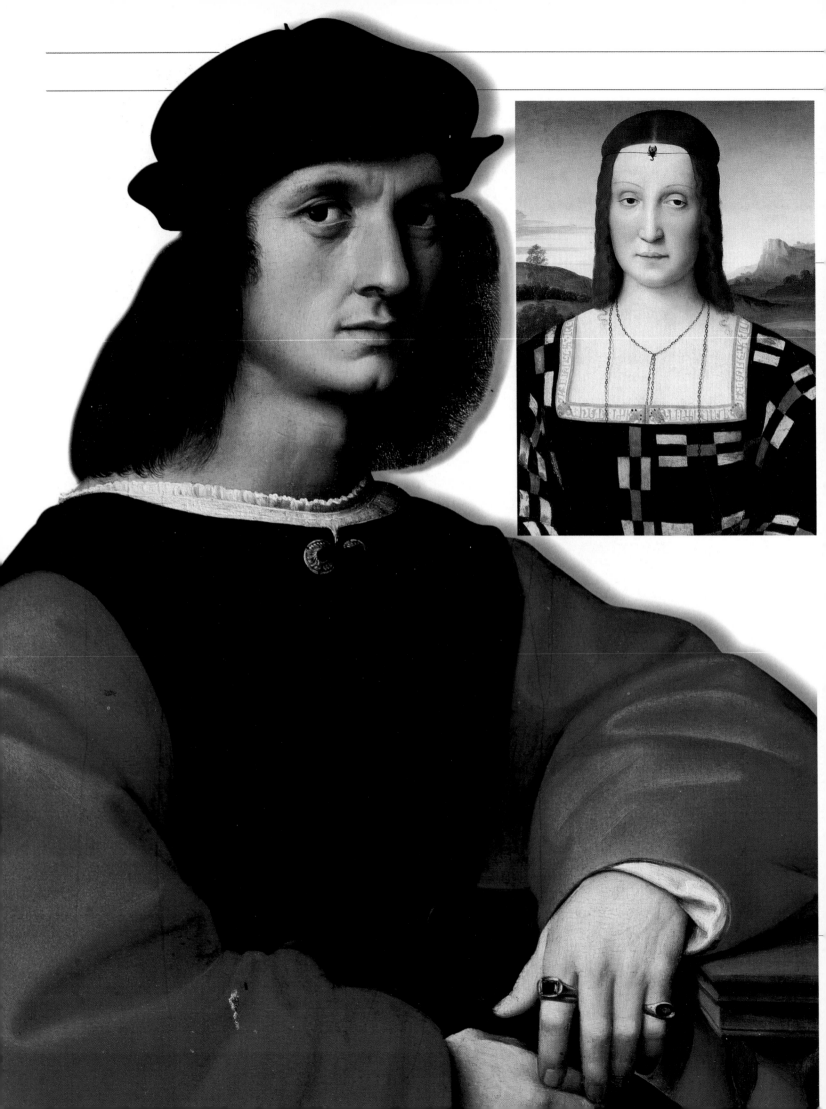

◆ PORTRAIT OF
ELISABETTA GONZAGA
(1504-05,
Florence, Uffizi)
Raphael immortalized
Elisabetta Gonzaga,
Duchess of Urbino
and patron of the arts.
Held by the Uffizi
Gallery in Florence
the portrait,
greatly enriched
by the 15ᵗʰ-century
gown, features cryptic
letters written
on the square neckline
of the dress and
a jewel with a scorpion
on the Duchess'
forehead, both
elements alluding
to her interest
in astrology.

◆ POTRAIT OF A WOMAN
(LA FORNARINA)
(1518-19, Rome,
Galleria Borghese).
Raphael portrayed
the woman he loved
as a chaste nude.
Margherita Luti was
from Siena, and the
daughter of a baker
in the Santa Dorotea
quarter of Rome.

◆ PORTRAIT
OF AGNOLO DONI
(1506-07,
Florence, Uffizi)
One of Raphael's early
portraits, executed
while he was living and
working in Florence.
The gentle refinement
associated with his
master Perugino and
the recently discovered
intensity of expression
favored by Leonardo,
are both evident here.

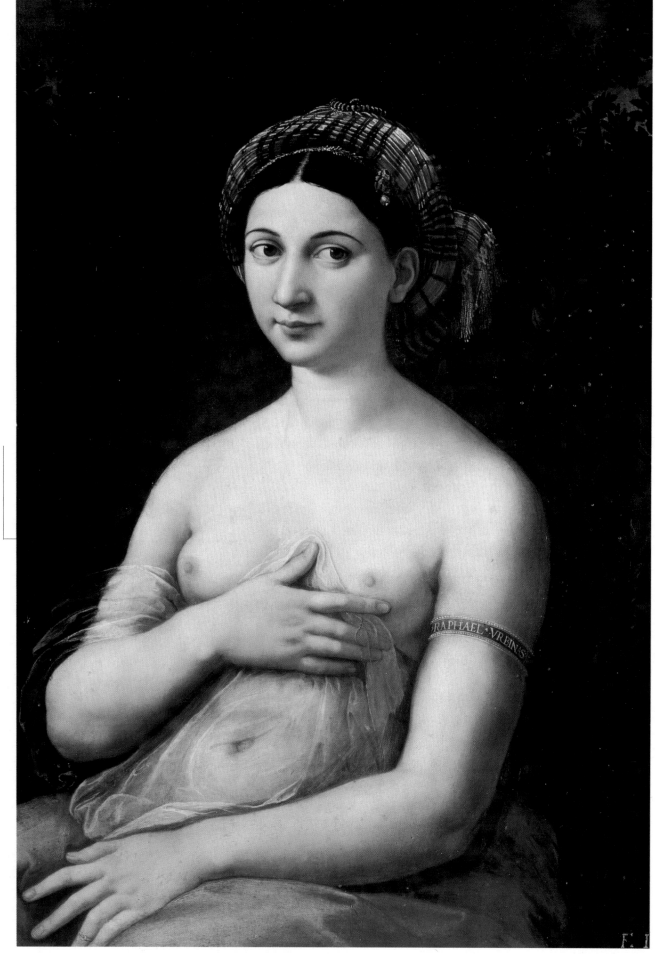

DIVINE GRACE

The first *Madonna and Child* by Raphael is most probably the fresco dating from 1496-97 in Raphael's father's house in Urbino. Previously attributed to his father, this Madonna who is reading with the Holy Infant asleep on her knee can in fact be considered one of Raphael's early works, above all because of the intense colors used for the Madonna's robe, which contrast with the pale flesh tones.

● In 1505, the young Raphael had grown tired of the provincial atmosphere in Perugia and, with a letter of introduction from Giovanna Feltria, the sister of the Duke of Urbino, left for Florence, eager to study the great tradition of Tuscan painting.

● Here he met Leonardo and Michelangelo and, inspired by their works, dedicated himself to draughtsmanship, trying to discover the harmonious laws on which the beauty of nature is founded. The famous series of Madonna paintings was executed between 1505 and 1508. In the *Madonna and Child* (known as the *Madonna del Granduca*), the *Small Cowper Madonna* and the *Madonna of Orléans* Raphael, influenced by Leonardo, furthered his study of sfumato, harmonious lines and the relationship between figures. The composition is enriched by a subtle vibrancy and brilliant luminosity.

● His brilliant capacity for assimilation, which enabled him to cull only the most significant elements of each painter, led him to study the Michelangelesque style. From 1506 onwards, Michelangelo was in Rome but he left in Florence the renowned *Tondo Doni* that Raphael was able to admire by frequenting the house of the family who commissioned it. The dynamic composition, twisting figures and new plastic strength of the volumes in the *Virgin and Child with St John the Baptist* (known as *La Bella Giardiniera*), painted in 1507, derive from the pictorial concept of the great master.

◆ VIRGIN AND CHILD WITH ST JOHN THE BAPTIST (known as the *Madonna del Prato*) (1506, Vienna, Kunsthistorisches Museum) Raphael accentuates the imposingness of the figure of the Holy Virgin, who is distinguished by her natural pose and sweet expression. Left, *Madonna and Child*, Raphael's first Madonna, dating from 1496.

◆ MADONNA AND CHILD (known as the *Madonna del Granduca*) (1506, Florence, Palazzo Pitti) When Grand Duke Ferdinand III took possession of the painting in 1799, he never wanted to be separated from it. Below, the preparatory drawing for the painting, now in the Gabinetto dei Disegni e delle Stampe degli Uffizi in Florence.

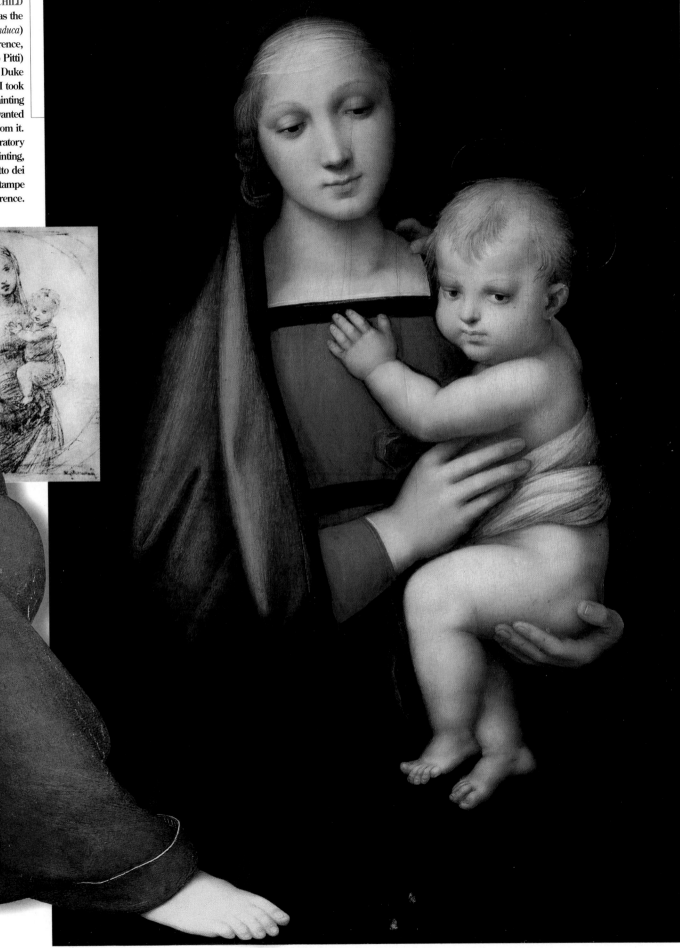

PRODUCTION: THE MADONNAS

28

◆ SACRA
CONVERSAZIONE
(MADONNA
DELL'IMPANNATA)
(1513, Florence,
Palazzo Pitti)
The Virgin, the Holy
Infant and young St John
are assisted by Saints
Elizabeth and Catherine.
In the background,
there is the covered
("impannato") window
from which the painting
takes its name.

◆ MICHELANGELO
BUONARROTI
Tondo Doni
(1504,
Florence, Uffizi)
Raphael discovered
the Michelangelesque
tondo while visiting
the house of Agonolo
and Maddalena Doni
in Florence. He was
impressed by the
variety and refinement
of the poses.

◆ VIRGIN AND CHILD
WITH ST JOHN THE
BAPTIST
(known as
La bella giardiniera)
(1508, Paris, Louvre)
A brilliant capacity
for assimilation
led Raphael to study
the style of the *Tondo
Doni*. The dynamic
composition, twisting
figures and new plastic
strength of the volumes
in *La Bella Giardiniera*
(1507) in fact derive
from Michelangelo.

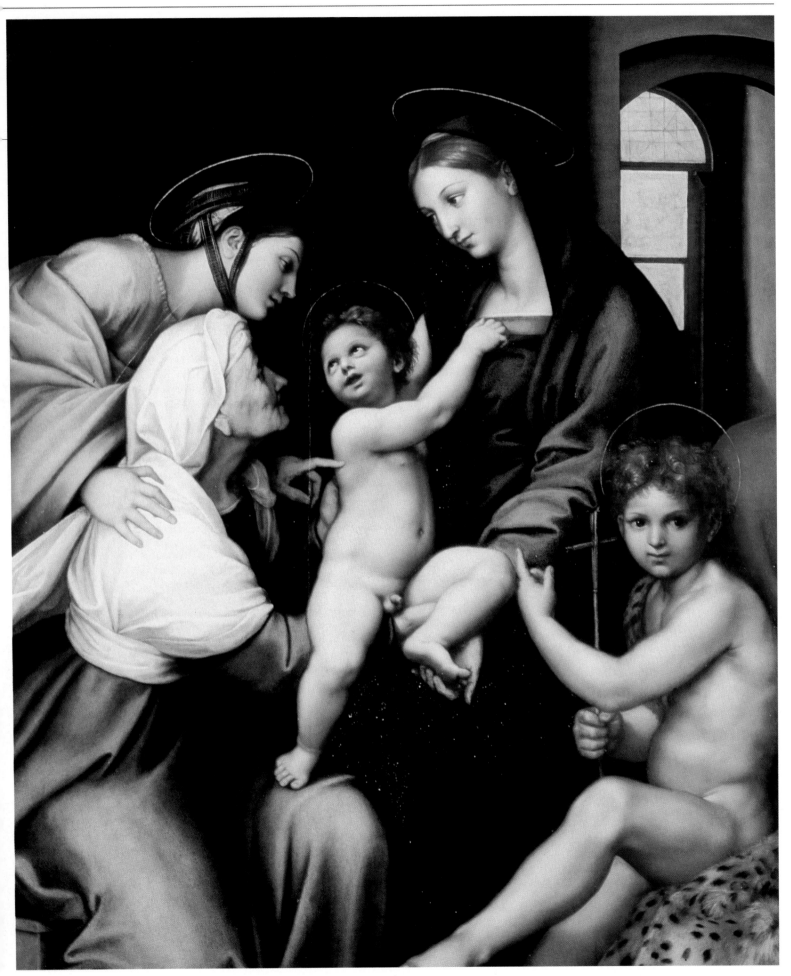

RELIGIOUS SUBJECTS

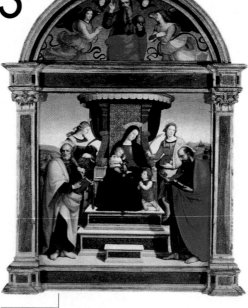

The first altarpiece of which we have evidence is the *Altarpiece of St Nicholas of Tolentino*, painted for the Andrea Baronci Chapel in the Church of Sant'Agostino in Città di Castello. The name of the painter Evangelista di Pian di Mileto also appears in the contract, stipulated on 10 December 1500. This altarpiece is already characterized by the precise draughtsmanship associated with Raphael throughout his career, which endows the figures with a delicate and sensitive quality.

● When the reputation he had gained with his early works spread to Perugia, the noblewoman Alessandra degli Oddi commissioned from Raphael, in 1502, an altarpiece —the *Oddi Altarpiece* with a *Coronation of the Holy Virgin* for the family chapel in the Church of San Francesco in Perugia. The supreme quality of the work, which can be seen in the spatial composition and the individual characterization of the figures, denotes a mature style far removed from the influence of Perugino.

● In the *Colonna Altarpiece* and the *Ansidei Altarpiece*, executed for the city of Perugia when Raphael was already in Florence, the young painter introduces new compositional forms that eliminate the setting and break down in the former work and reconstruct in the latter, the traditional pyramidal structure generally applied to the subject of the Madonna and Child with saints.

● Raphael's sensibility reached its height, however, in *Deposition* (*Baglioni Altarpiece*) painted in 1508-09, during his Rome period. Commissioned by Perugian noblewoman Atalanta Baglioni in memory of her son Grifonetto, assassinated a few years previously, and destined for the Church of San Francesco al Prato in Perugia, the altarpiece denotes the transition from provincial circles to a new cultural life in Rome. The powerful volumes, theatrical poses, and dramatic torsion of the bodies, are reminiscent of Michelangelo. Raphael immortalizes the dead Grifonetto in the figure of the bearer who, strong and imposing, is central to the action and the fulcrum of all movement. In the preparatory drawing the face of the bearer is different to the one in the altarpiece, which is evidently a portrait of the young Baglione.

● In subsequent altarpieces depicting *St Cecilia in Ecstasy* (1514-16), destined for Bologna, and the *Sistine Madonna*, painted during the same period, Raphael adopted the theatrical genre, which accentuated scenic effects to reveal God to the viewer and to move his innermost spirit.

◆ MADONNA AND CHILD ENTHRONED WITH FIVE SAINTS (COLONNA ALTARPIECE) (1503, New York, Metropolitan Museum) Saints Peter and Catherine, on the left, and Saints Margaret and Paul, on the right, assist the Madonna and Child. The nuns of Sant'Antonio in Perugia commissioned the altarpiece, specifying that the Holy Infant and the young St John be clothed. The composition is strictly frontal, but Raphael has broken down the traditional pyramidal structure.

◆ DEPOSITION (1508, Rome, Galleria Borghese) The noblewoman Atalanta Baglioni commissioned this altarpiece in memory of her son Grifonetto who was murdered. Raphael was inspired by the tense expressions and twisting bodies typical of the Michelangelesque style, and classical interpretations of power and movement. Below, the preparatory drawing that is now in the Gabinetto dei Disegni e delle Stampe degli Uffizi in Florence.

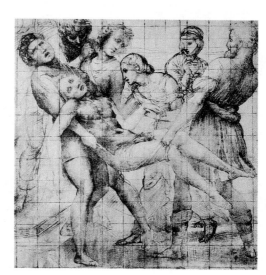

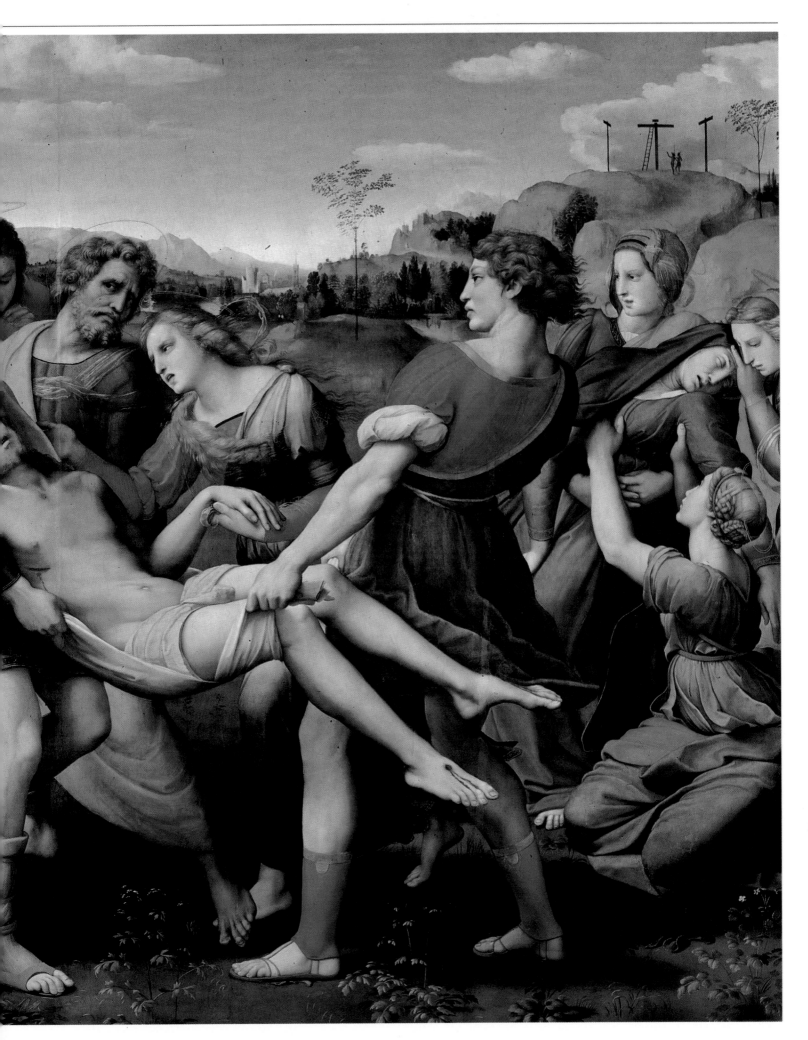

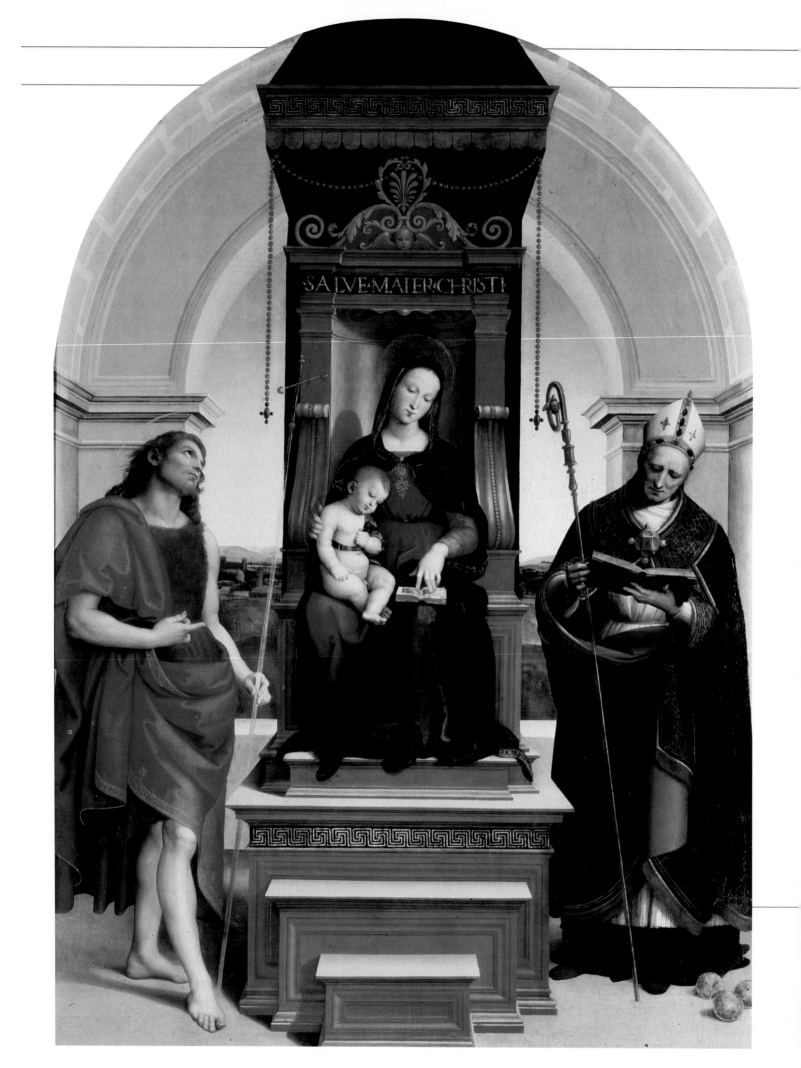

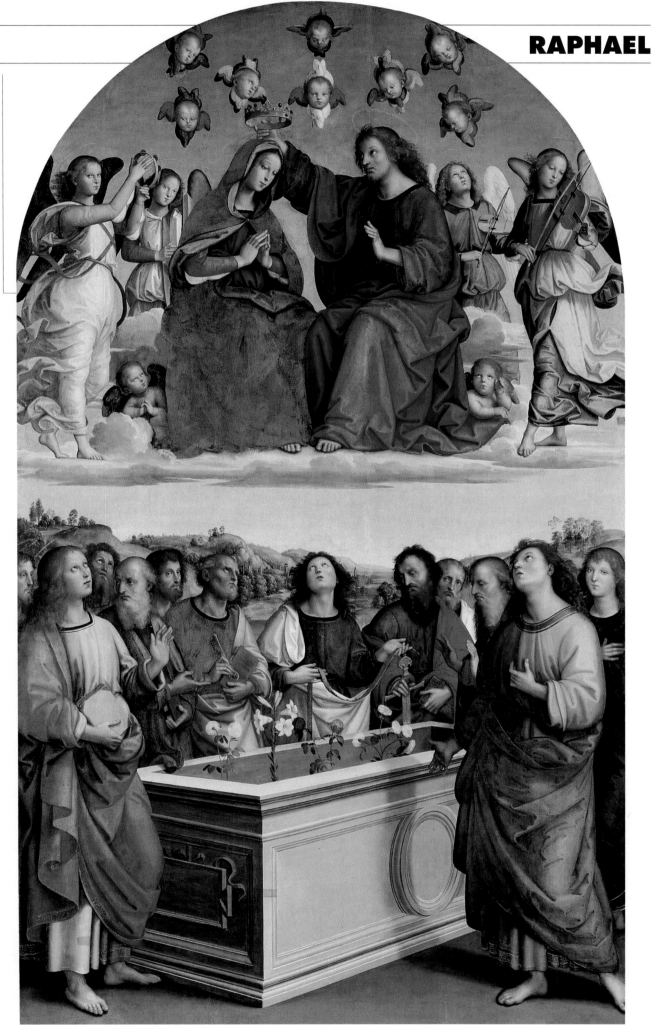

◆ CORONATION OF THE HOLY VIRGIN (ODDI ALTARPIECE) (1502-03, Rome, Pinacoteca Vaticana) The Oddi Altarpiece is composed of a *Coronation of the Virgin*, an *Annunciation*, an *Adoration of the Magi* and a *Presentation at the Temple*. Commissioned by Alessandra degli Oddi for the Church of San Francesco in Perugia, the altarpiece was requisitioned in 1797 by the French and taken to the Louvre. It was returned to Italy in 1815 and displayed in its present setting. The spatial composition and the individual characterization of the figures, denote a mature style that far removed from the influence of Perugino.

◆ MADONNA ENTHRONED (ANSIDEI ALTARPIECE) (1504-06, London, National Gallery) Saints John the Baptist and Nicholas of Bari appear in this altarpiece executed for the Church of San Fiorenzo dei Serviti in Perugia. The simple architectural setting is reduced to a single, large, luminous arch, and the figures are arranged more imposingly than in Perugino's paintings.

MAJOR COMMISSIONS

Between 1508 and 1520 Raphael worked for two celebrated patrons in Rome: the Pope, who appointed him to decorate his apartments in the Vatican, and wealthy Sienese banker Agostino Chigi, for whom he frescoed Villa Farnesina in Rome. The two commissions were both ambitious culturally-demanding projects.
● At the Vatican, Raphael worked on the four rooms of Julius II's apartments. In the first, the Stanza della Segnatura, on which he was engaged from 1508 to 1511, he portrayed the Heavenly Court in the *Disputation Concerning the Blessed Sacrament* and the temple of philosophy in the *School of Athens*. In the second room known as the Stanza d'Eliodoro, begun in 1511 and finished in 1513, he painted the dramatic frescoes of the *Expulsion of Heliodorus from the Temple*, the *Miracle of the Mass at Bolsena*, the *Liberation of St Peter* and the *Encounter between Attila and Leo the Great*. Following the death of Julius II, his successor Pope Leo X renewed Raphael's contract and he was able to begin decorating the third room, the Stanza dell'Incendio, in 1514. Here the painter evokes the dramatic episode of the *Fire in the Borgo*. On the other walls we find the *Coronation of Charlemagne, Leo IV's Naval Victory over the Saracens at Ostia* and the *Investiture of Leo III*. The last room, known as the Stanza di Costantino, which contains the *Baptism of Constantine*, the *Battle of the Milvan Bridge*, the *Apparition of the Cross* and the *Donation of Constantine*, was almost entirely decorated under Clement VII by the assistants of Raphael, who died suddenly, leaving only the drawings of the frescoes.
● Already an established painter, the young Raphael was called in 1511 by the nobleman Agostino Chigi who, wishing to give his new summer residence, the Farnesina on the Lungotevere, the appearance of an ancient patrician villa, decided to decorate all the rooms, etc., with frescoes. Here Raphael painted the ceiling of the loggia and the *Triumph of Galatea*, according to the classical style in vogue in the literature of the period. The Chigis invited aristocrats, artists, princes, diplomats, the higher clergy and men of letters to the villa. The decoration had to evoke the classical culture of the ancient capital of the Roman empire.

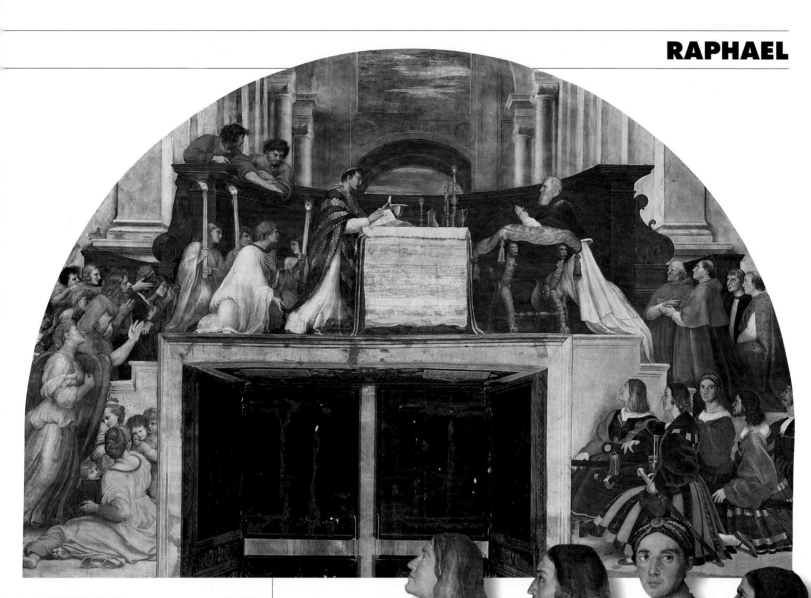

◆ FIRE IN THE BORGO
(1514, *Stanza dell'Incendio*, Rome, Vatican)
The heroic acts of Leo III and Leo IV inspired the political allegories in the frescoes of the *Stanza dell'Incendio*. Raphael portrays in this dramatic composition in a historical and allegorical key, the fire that devastated the Borgo of the Vatican in 847. The narrative alludes to classical events. In the foreground, on the left, Aeneas is depicted with his father Anchises on his shoulders and his son Ascanius by his side, as they flee from a burning Troy.

◆ MIRACLE OF THE MASS AT BOLSENA
(1512, *Stanza di Eliodoro*, Rome, Vatican)
In the *Stanza di Eliodoro* Raphael evokes the miracle of the blood that poured from the Host during the celebration of a Mass at Bolsena in 1263. The painter brings a topicality to the event by portraying Julius II, kneeling on the right, and his colorful entourage of prelates, cardinals and Swiss guards (see detail on right). The ceiling of the room is decorated with allegorical and biblical scenes linked to the episodes on the walls.

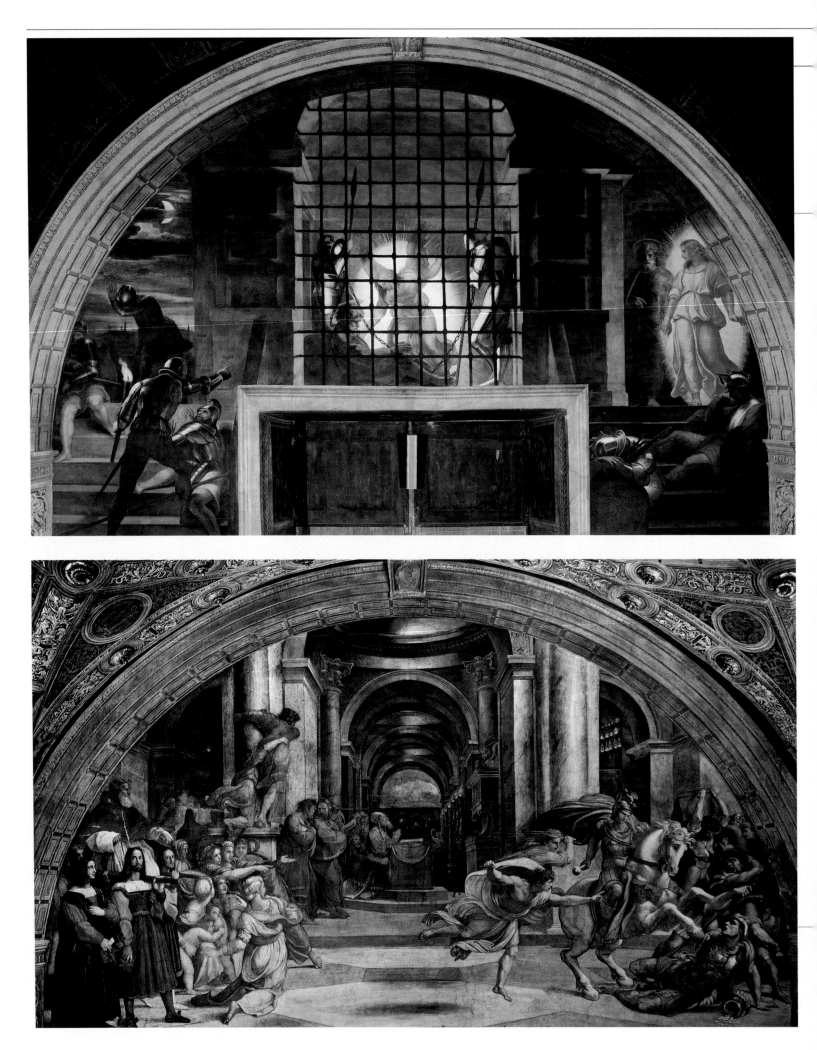

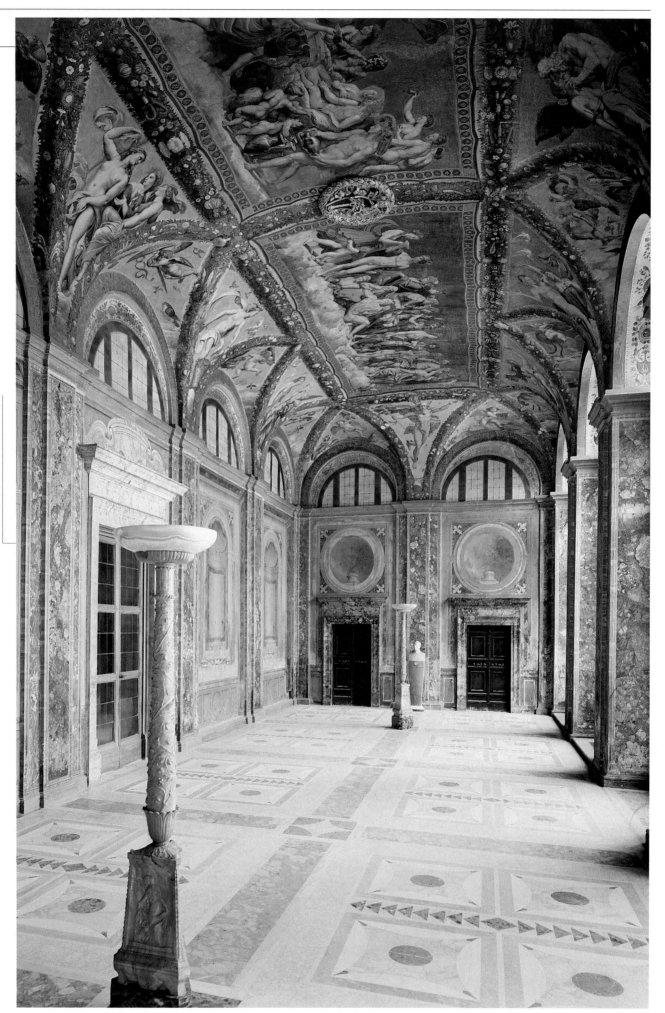

◆ **LIBERATION OF ST PETER** (1513, *Stanza di Eliodoro*, Rome, Vatican) The fresco has been interpreted as the death of Pope Julius II, which occurred in February 1513. St Peter has the face of Julius II, sleep represents death, and the angel and the light symbolize both the resurrection and entrance into Paradise.

◆ **LOGGIA OF PSYCHE** (1517, Rome, Villa La Farnesina) Built by Baldassarre Peruzzi in 1508 for the banker Agostino Chigi, the Farnesina has decorations by Raphael in the *Loggia of Psyche*, and in particular in the room with the famous fresco *The Triumph of Galatea*. Raphael's pupils Giulio Romano and Giovanni da Udine participated in the work, along with Sebastiano del Piombo and Sodoma.

◆ **EXPULSION OF HELIODORUS FROM THE TEMPLE** (1512, *Stanza di Eliodoro*, Rome, Vatican) Heliodorus entered the temple at Jerusalemto steal the sacred vessels and was driven out by the guardian angels. This theme symbolizes the way in which God miraculously intervenes to help the Church.

THE RETURN TO ANTIQUITY

Following Bramante's death, Pope Leo X appointed Raphael to succeed the Lombard as Head of the Fabric of St Peter's. Where and when Raphael acquired his architectural skills we do not know. We can only suppose that he gained experience as a youth with Francesco di Giorgio Martini—a friend of his father and the greatest architect at the court of Urbino— and take into account the scrupulous attention he gave to the formal aspect of the idealized architecture in his paintings. Already in the *Betrothal of the Virgin* (1504), the entire upper part of the composition was dedicated to the portrayal of a round temple. In the *School of Athens*, the gathering of the philosophers takes place in an imposing, open architectonic space.

● Raphael's first architectural project was the Chigi Chapel in Santa Maria del Popolo in Rome, a construction modeled on classical principles, and on the rotunda known as the Pantheon, in particular.

● A drawing by Parmigianino shows the façade of Palazzo Branconio dell'Aquila, designed by Raphael in the area of Borgo Pio and destroyed to make room for the colonnade of St Peter's by Bernini. The façade was decorated with ancient sculpture in two-tone *trompe l'oeil*. In Rome, Raphael also worked on the Church of Sant'Eligio degli Orefici and the new design for the Basilica of St Peter, substituting Bramante's original Greek cross plan with a Latin cross design.

● In 1519, he designed Villa Madama in Monte Mario, Rome, for Cardinal Giulio de' Medici, drawing inspiration from the ancient Roman villa. We can also assume that he was active as an architect in Florence, as he submitted plans for Palazzo Pandolfini and entered the competition for the façade, still incomplete, of the Church of San Lorenzo.

◆ DONATO BRAMANTE
Project for the Basilica of St Peter
(1504, Rome)
Appointed by Pope Julius II, in the world Giuliano della Rovere, Bramante worked on the Fabric of St Peter's from 1508 until his death, in 1513. His design for St Peter's was based on a Greek cross plan.

◆ LOGGIAS OF THE VATICAN
(1512-20, Rome)
Begun by Bramante for Julius II, the Loggias were completed by Raphael, who devised the stucco and fresco decoration. As chief supervisor, he guided his assistants (Giovanni da Udine, Giulio Romano, Tommaso Vincidor, Giambologna, Perin del Vaga, Polidoro da Caravaggio) and supplied the preparatory drawings.

◆ PLAN FOR THE BASILICA OF ST PETER
(1514)
Following his appointment as Superintendent of Antiquities by Pope Leo X, Raphael succeeded Bramante as Head of the Fabric of St Peter's in 1514. His plan incorporated a basilican plan, based on a Latin cross, with three aisles.

♦ **STUDIES FOR WINDOWS IN THE BASILICA OF ST PETER** (1515, Florence, Uffizi, Gabinetto dei Disegni e delle Stampe) Raphael's design for the Basilica of St Peter comes down to us in the *Treatise on Architecture* by Serlio. When Pope Leo X appointed the young painter as Head of the Fabric of St Peter, he supplied him with two assistant architects: Fra' Giocondo and Giuliano da Sangallo. When Raphael died in 1520, Antonio da Sangallo took over, assisted in his turn by Baldassarre Peruzzi.

♦ **PARMIGIANINO** *Drawing of Palazzo Branconio dell'Aquila by Raphael Sanzio* A drawing by Parmigianino testifies to the fact that Raphael built this mansion in the area of Borgo Pio, which was later destroyed to make room for the colonnade by Gian Lorenzo Bernini. Raphael's penchant for the classical style can be seen in the marble and stuccowork on the façade. As Superintendent of Antiquities he was responsible for the conservation of the ancient treasures in Rome.

TOWARDS THE NEW WORLD

Raphael Sanzio was born on 6 April 1483 and died prematurely in 1520. He lived in a period of great political, artistic and social ferment. As child he witnessed the beginning of the great journeys around the world that led to the discovery of new lands. In 1487, the Portuguese navigator Bartholomeu Diaz rounded the Cape of Good Hope, and in 1492 Christopher Columbus, supported by the Spanish Crown, set sail with the intention of establishing a western route to the Indies, and discovered San Salvador Island, the Bahamas and Cuba. Meanwhile, Vasco da Gama had reached the Indies by circumnavigating Africa (1497-98).

● The Catholic Church experienced a profound crisis due to the affirmation of new religious theories, which it sought to repress severely. The Pope reintroduced the Inquisition.

● A harsh blow was inflicted by Martin Luther, who nailed his *95 Theses* to the church door at Wittenberg, in 1517. Excommunicated in 1521, at the Diet of Worms he advocated a "justification by faith," a doctrine that excluded the clergy's intervention in man's salvation. Luther's attacks on the Catholic Church led to the rejection of papal authority and marked the beginning of the Protestant Reformation. The new doctrine was embraced by many

◆ PORTRAIT OF PERUGINO
(1495-96,
Florence, Uffizi)
Initially held to be a portrait of Luther by Holbein the Younger, and then by Verrocchio, the subject was finally identified as Perugino and the painting attributed to Raphael.

◆ MICHELANGELO BUONARROTI
La Pietà
(1499, Rome, Basilica of St Peter)
Commissioned by Alexander VI, *La Pietà* marks Michelangelo's departure from classical themes. Nevertheless, the sculpture still embodies the Quattrocento pyramidal composition favored by Jacopo della Quercia and Verrocchio.

◆ OTTAVIO VANNINI
Lorenzo the Magnificent among Artists
(1635, Florence, Palazzo Pitti)
Lorenzo the Magnificent, so called because of the splendor of his rule was a patron and cultivator of the arts. Artists always found hospitality and protection at his court in Florence. He died in 1492.

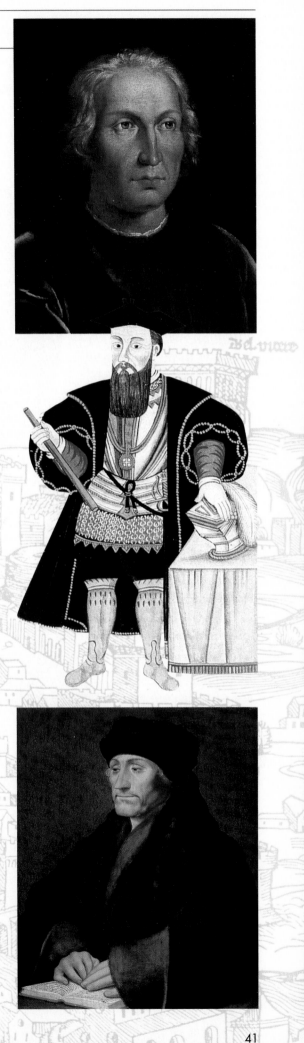

princes, mainly because of its political implications. In 1508 the humanist scholar Erasmus of Rotterdam had already written his *Encomium Moriae*, a satire on the corruption of the Church and on academic philosophy.

● Raphael was summoned to Rome in 1508, to celebrate, in historical and allegorical frescoes, the glory of the faith and of the papacy, and to propagandize with his most elevated works of art, a universal order that was only possible under the Church.

● The political situation in Italy was very delicate. In 1492 Lorenzo the Magnificent died, the Medici were driven out of Florence, and Savonarola set up a government of the people based on the principles of democracy. He was condemned to death in 1498, as a result of his sermons that were critical of papal corruption. In 1499 the French King Louis XII entered Italy, and Pope Julius II had the task of confronting the enemy. A new threat was posed by Charles V who, having inherited the Spanish throne in 1516 and had himself proclaimed Holy Roman Emperor in 1519, intended to extend his dominions to Italy.

● During his brief lifetime, Raphael saw four members of the wealthiest noble families ascend to popedom: Innocent VIII Cybo who in 1485 supported a conspiracy to depose Ferdinand I, King of Naples; Alexander VI Borgia who sought to make his son Valentino ruler of central Italy; Julius II della Rovere, the "Warmongering Pope" who with the League of Cambrai of 1508, led the war against Venice and with the Holy League of 1511, waged war on France; Leo X de' Medici, who decreed plenary indulgence to gather financial contributions for the Fabric of St Peters.

● The destinies and works of the greatest geniuses of the time were closely linked to the individual popes. In 1499 Michelangelo sculpted, at the age of twenty-four, the *Pietà* in St Peter's for the Borgia pope Alexander VI, and in 1512 he completed the frescoes in the Sistine Chapel for Julius II. In 1506 Donato Bramante was called upon by the latter to design the new St Peter's. From 1508 until his death, Raphael worked on the Stanze, and in 1514 he redesigned the basilica of the Vatican.

THE ULTIMATE MODEL

For a long time Raphael was the ultimate model for many painters of his generation and the next. Following his untimely death, the artists who had trained in his workshop completed the works he had begun and left unfinished, spreading his pictorial style throughout the Cinquecento.

● Giulio Romano, Perin del Vaga and Polidoro da Caravaggio, the immediate heirs to the Raphaelesque legacy, made his principles their own and when they fled from Rome following the Lansquenets' dramatic descent on Rome, took the pictorial language of the young master to the courts of Mantua, Genoa and Naples, respectively. Thus an artistic "koine" of Roman origin was formed that was called—sometimes deprecatingly—"Mannerism."

● To defend itself from Luther's new Protestant theories, the Church of Rome adopted the harmonious elements of the Raphaelesque style as the principal weapon of its Counter-Reformation. The pictorial model of Raphael, the divine youth, was considered the perfect example throughout the following century, to the extent that it was studied exhaustively by Baroque artists, who sought to accentuate the theatrical quality of his late works (like the *Sistine Madonna*).

● His concepts were assimilated also in the Iberian Peninsula, thanks to the experience gained in Italy by two Spanish painters, Alonso Berruguete and Pedro Machuca, who met Raphael in Rome. To learn his technique they worked with the young apprentices in his workshop, collaborating on the decoration of the ceiling in the Stanza di Eliodoro in the Vatican.

● In the mid-nineteenth century, when the style of the Middle Ages was revived in Europe, the English Pre-Raphaelite Brotherhood conducted a campaign against the Cinquecento painter, accusing him of having denied the spiritual aspect of painting and making it merely formal research. A few decades previously, the German Nazarener had taken Raphael's early works as their artistic model.

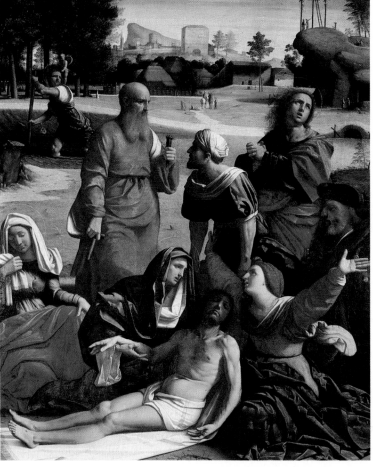

◆ GIULIO ROMANO
Fall of the Giants
(1525, Mantua, Palazzo Té).
The greatest masterpiece
by Raphael's most
important pupil
at the court of Mantua.
The painting presents
an illusionistic
and anguished image
of the collapse of the titans.

◆ ALONSO BERRUGUETE
Madonna and Child
(1516, Florence,
Palazzo Vecchio).
The Spanish painter was
influenced by Raphael
and his *Madonna and
Child with St John* (known as
the *Madonna della Seggiola*)
(1514, Palazzo Pitti,
Florence, tondo on far left).

◆ SISTINE
MADONNA
(1515, Dresden,
Gemäldegalerie, detail)
On the opposite page
are the two angels that
are perhaps the most
well-known elements
of Raphael's iconography.

◆ GIAMBATTISTA
BENVENUTI
(L'ORTOLANO)
Deposition
(1522, Museo di
Capodimonte, Naples)
The Ferrarese painter was
inspired by the classicism
in Raphael's painting.

THE ARTISTIC JOURNEY

For a vision of the whole of Raphael's production, we propose here a chronological reading of his principal works.

◆ CORONATION OF ST NICHOLAS OF TOLENTINO (1500)

At the age of seventeen Raphael was already referred to as a *magister* in the contract for this altarpiece for the Andrea Baronci Chapel in the Church of Sant'Agostino at Città di Castello. Today only four fragments remain, and are held by the Pinacoteca Tosio Martinengo in Brescia. The characteristics of Raphael's late works are already evident.

◆ MADONNA AND CHILD (1496-97)

Previously attributed to Raphael's father Giovanni Santi, this small fresco of a *Madonna and Child* is painted on a wall in Santi's house in Urbino and in fact displays traits associated with Raphael's painting. The rendering of the volume, the natural relationship between mother and son and the use of intense color for the mantle in contrast with the soft flesh tones, are in fact typically Raphaelesque.

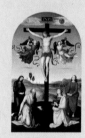

◆ MOND CRUCIFIXION (1503)

Commissioned by Tommaso Gavari for the Church of San Domenico in Città di Castello, the altarpiece, now in the National Gallery in London, bears the signature "RAPHAEL VURBINAS P" on the foot of the cross, but is not dated. On the altar above which it hung there was a dedication with the date "1503," which was therefore considered to be the date of execution. The painting bears the unmistakable stamp of Perugino.

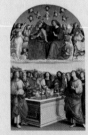

◆ CORONATION OF THE HOLY VIRGIN (ODDI ALTARPIECE) (1502-03)

The noblewoman Alessandra degli Oddi asked Raphael to paint this work for the family chapel in the Church of San Francesco in Perugia. The altarpiece is now in the Pinacoteca Vaticana, to which it was returned after being requisitioned by the French in 1797. It is composed of a *Coronation of the Holy Virgin* and a predella with an *Annunciation, Adoration of the Magi* and *Presentation at the Temple*.

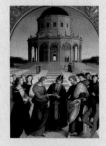

◆ BETROTHAL OF THE HOLY VIRGIN (1504)

This is the work by Raphael that comes closest to the style of Perugino, and was probably inspired by his *Marriage of the Holy Virgin* in the Musée des Beaux-Arts in Caen. The painting was commissioned by a well-to-do citizen of Città di Castello and is now held by the Pinacoteca di Brera in Milan. The architecture in the background is inspired by the Tempietto of San Pietro in Montorio, designed by Bramante.

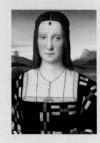

◆ PORTRAIT OF ELISABETTA GONZAGA (1504-05)

In this painting Raphael immortalized Elisabetta Gonzaga, Duchess of Urbino and patron of the arts. Held by the Uffizi Gallery in Florence, the portrait, greatly enriched by the 15th-century gown, features cryptic letters written on the square neckline of the dress and a jewel with a scorpion on the Duchess' forehead, both elements alluding to her interest in astrology.

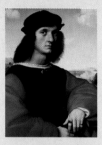

◆ PORTRAIT OF AGNOLO DONI (1506-07)

Raphael's early patrons included Agnolo Doni and his wife Maddalena, two of the leading figures in Florentine society, whom Raphael portrayed according to Flemish models. Perugino-style motifs in the figure of the man and a new Michelangelesque influence in the volumes of the woman's body, are combined with a detailed reproduction of the rich attire and jewelry that symbolized the opulence of a complaisant bourgeoisie.

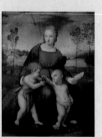

◆ MADONNA OF THE GOLDFINCH (1506)

The painting was commissioned by the upper-middle-class Florentine Lorenzo Nasi and Sandra di Matteo di Giovanni Canigiani for their wedding, celebrated between the end of 1505 and the beginning of 1506. Thirty years later, the painting was damaged when the ceiling of their house fell in, and broke into seventeen pieces. The influence of Leonardo, whom Raphael met in Florence, is evident. This Madonna is now held by the Uffizi.

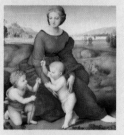

◆ VIRGIN AND CHILD WITH ST JOHN THE BAPTIST (1506)

Executed in Florence for Taddeo Taddei, the painting is dated "1506" in Roman numerals on the neckline of the Virgin's dress. Since the eighteenth century it has been part of the Viennese imperial collections and has often been called the *Madonna del Belvedere*. Even though the work reflects the Leonardesque spirit, the impressive graphic element makes it outstanding. The painting is now in the Kunsthistorisches Museum in Vienna.

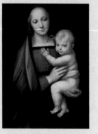

◆ MADONNA AND CHILD (1506)

The painting takes its name from Ferdinand III of the house of Habsburg-Lorraine, who bought it from the painter Carlo Dolci in 1799. Influenced by Leonardo, Raphael furthered his study of sfumato, harmonious lines and the relationship between figures. The composition is enriched by a subtle vibrancy and brilliant luminosity. The painting is on display in the Galleria Palatina in Florence.

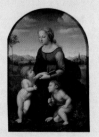

◆ VIRGIN AND CHILD WITH ST JOHN THE BAPTIST (1508)

Raphael's brilliant capacity for assimilation led him to study the Michelangelesque style. In 1506 Michelangelo left in Florence the renowned *Tondo Doni* that Raphael was able to admire. The dynamic composition, twisting figures and new plastic strength of the volumes in *La Bella Giardiniera* (1507) derive from the pictorial concept of the Florentine master. The work is held by the Louvre in Paris.

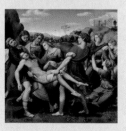

◆ THE DEPOSITION (1508)

Commissioned by Perugian noblewoman Atalanta Baglioni in memory of her son Grifonetto and destined for the Church of San Francesco al Prato in Perugia, the altarpiece derives from the Michelangelesque style that can be seen in the powerful volumes, and dramatic torsion of the bodies. Raphael immortalizes the dead Grifonetto in the figure of the bearer. The painting is in the Galleria Borghese in Rome.

◆ SCHOOL OF ATHENS (1509-11)

The cornerstone of the decoration in the apartments of Pope Julius II in the northern wing of the Vatican Palace, the painting represents the temple of Greek philosophy, and is the undisputed masterpiece of rational Renaissance perspective. At the dawn of the Cinquecento, when humanistic creativity was at its height, Raphael portrayed man's return to the center of the universe.

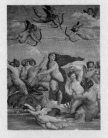

◆ TRIUMPH OF GALATEA (1509)

Commissioned by nobleman Agostino Chigi to decorate his new summer residence—the Villa Farnesina on the Lungotevere— in 1511, Raphael drew his inspiration from ancient patrician villas. He portrayed the *Triumph of Galatea* in the classical style fashionable in the literature of the period, and his decoration evokes the classical culture of the ancient capital of the Roman empire.

◆ PORTRAIT OF CARDINAL INGHIRAMI (1509)

Chief librarian of the Biblioteca Vaticana from 1510 onwards, Tommaso Inghirami was nicknamed "Phaedra" because he liked to recite classical tragedies and plays, as was the custom at the time. Held by the Galleria Palatina in Florence, the sharp, realistic imagery of the portrait closely links it stylistically to those of Maddalena and Angelo Doni.

◆ POPE JULIUS II (1512)

The portrait was donated by the Pope himself to the Church of Santa Maria del Popolo in Rome. Julius II grew a beard after the convening of the Council of Pisa at the end of 1511, through which Louis XII of France intended to depose him. The episode was fundamental to dating the painting, now held by the National Gallery in London.

◆ DOUBLE PORTRAIT (1512)

Held by the Louvre in Paris, the painting could be described as a self-portrait with friend. Here Raphael has a full beard and his hair is parted in the middle, which made his contemporaries even more convinced of his physical and spiritual resemblance to Christ. The pose and Christ-like aspect derive from Dürer's *Self-Portrait* as *Ecce Homo*.

◆ LIBERATION OF ST PETER (1513)

The fresco, which is part of the decoration in the Stanza di Eliodoro in the Vatican apartments, has been interpreted as the death of Pope Julius II, which occurred in February, 1513. St Peter has the face of Julius II, sleep represents death, and the angel and the light symbolize the resurrection and the entrance to Paradise.

◆ MADONNA AND CHILD WITH ST JOHN (1513)

This small painting was commissioned by the newly-elected Pope Leo X, who succeeded Julius II. It portrays the Virgin with the Holy Infant and little St John and is held by Palazzo Pitti in Florence. The chair in which the Madonna is sitting is similar to that used by the popes and her head-dress in the form of a turban was all the fashion with Roman noblewomen in the sixteenth century.

◆ SISTINE MADONNA (1515)

The altarpiece is held by the Gemäldegalerie in Dresden. The Madonna and Child are theatrically framed by a curtain, as if they had just made their entrance; two angels are looking over a railing; on either side Saints Sixtus and Barbara intercede on behalf of humanity, invoking grace from the Madonna. The painting influenced many Baroque painters, who sought to move the spirit of the faithful with striking theatrical effects.

◆ PORTRAIT OF BALDASSARRE CASTIGLIONE (1515)

Held by the Louvre in Paris, the portrait was executed during Raphael's Roman period—which was when he met Castiglione. The man's typically Flemish pose and the portrayal of the subject from the waist up, are quite unusual. The twist of the torso and arms creates spatial depth.

◆ PORTRAIT OF A WOMAN (LA VELATA) (1516)

When he painted his beloved, Margherita Luti from Siena who was the daughter of a baker in the Santa Dorotea quarter in Rome, Raphael abandoned himself to extremely luminous tones expressing human warmth. The gold, cream and white of her gown and the pale rosy flesh, light up the image of the young woman immortalized in *La Velata* in Palazzo Pitti and in the *Fornarina* on display in the Galleria Borghese.

◆ FIRE IN THE BORGO (1514)

The fresco is part of the decoration in the Stanza dell'Incendio. The Borgo of the Vatican was being devastated by fire and Pope Leo IV, looking out from the loggia, put out the flames with his blessing. In the foreground, on the left, Aeneas is depicted with his father Anchises on his shoulders and his son Ascanius by his side, as they flee from a burning Troy.

◆ POPE LEO X WITH CARDINALS GIULIO DE' MEDICI AND LUIGI DE' ROSSI (1518-19)

The painting is held by Palazzo Pitti in Florence and portrays Pope Leo X with the two Cardinals, who were possibly added later. Commissioned by the Pope, the portrait was destined to take his place at a family banquet. It is characterized by the rich color and bold play of chiaroscuro.

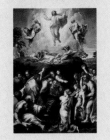

◆ TRANSFIGURATION (1518)

The painting was commissioned by Cardinal Giulio de' Medici for the Cathedral of Narbonne and was painted in competition with Sebastiano del Piombo. Vasari relates that the picture was above Raphael's bed when he died "and the sight of this living work of art along with his dead body made the hearts of everyone who saw it burst with sorrow." The painting is held by the Pinacoteca Vaticana.

◆ PALAZZO BRANCONIO DELL'AQUILA

All that remains of the *palazzo* is this drawing by Parmigianino. The palace was built in the area of Borgo Pio and demolished to make room for the Colonnade of St Peter's by Bernini. The façade was decorated with ancient sculpture in two-tone trompe l'oiel, and the palace itself was one of various architectural projects undertaken by Raphael.

TO KNOW MORE

The following pages contain: some documents useful for understanding different aspects of Raphael's life and work; the fundamental stages in the life of the artist; technical data and the location of the principal works found in this volume; an essential bibliography.

DOCUMENTS AND TESTIMONIES

Vasari's account

In 1550, Giorgio Vasari published a collection of monographies on artists, which is still the only document that sheds light on the careers of painters, sculptors and architects that otherwise would remain a mystery to us. In his Lives of the Artists, *he speaks of the grace and culture that distinguished Raphael's painting.*

"But the most graceful of all was Raphael of Urbino, who studied what had been achieved by both the ancient and modern masters, selected the best qualities from all their works, and by this means so enhanced the art of painting that it equaled the faultless perfection of the figures painted in the ancient world by Apelles and Zeuxis, and might even be said to surpass them were it possible to compare his work with theirs. His colors were finer than those found in nature, and his invention was original and unforced, as anyone can realize by looking at his scenes, which have the narrative flow of a written story. They bring before our eyes sites and buildings, the ways and customs of our own or of foreign peoples, just as Raphael wished to show them. In addition to the graceful qualities of the heads shown in his paintings, whether old or young, men or women [...]. And his draperies are neither too simple nor too involved but appear wholly realistic. With wonderful indulgence and generosity heaven sometimes showers upon a single person from its rich and inexhaustible treasures all the favors and precious gifts that are usually shared, over the years, by a great many people. This was clearly the case with Raphael Sanzio of Urbino, an artist as talented as he was gracious, who was endowed by nature with the goodness and modesty to be found in all those exceptional men whose gentle humanity is enhanced by an affable and pleasing manner, expressing itself in courteous behavior at all times and towards all persons.

Nature sent Raphael into the world after it had been vanquished by the art of Michelangelo and was ready, through Raphael, to be vanquished by character as well. [...] In Raphael [...] the finest qualities of mind were accompanied by such grace, industry, looks, modesty and excellence of character as would offset every defect, no matter how serious, and any vice, no matter how ugly. One can claim without fear of contradiction that artists as outstandingly gifted as Raphael are not simply men but, if it be allowed to say so, mortal gods..."

Concerning Raphael's death Vasari writes:

"Having made his confession and repented, Raphael ended his life on Good Friday, the same day he was born. He was thirty-seven when he died; and we can be sure that just as he embellished the world with his talent so his soul now adorns heaven itself.
As he lay dead in the hall where he had been working they placed at his head the picture of the Transfiguration which he had done for Cardinal de' Medici; and the sight of this living work of art along with his dead body made the hearts of everyone who saw it burst with sorrow. In memory of Raphael, the cardinal later placed this picture on the high altar of San Pietro in Montorio."
(trans. George Bull)

Two of Raphael's letters

Very few of Raphael's writings have come down to us. They include two letters, sent by the painter to Baldassarre Castiglione circa 1514 and to Pope Leo X in 1515 respectively, which are reproduced here. The subject of both is Raphael's appointment as Head of the Fabric of St Peter's.

"In honoring me His Holiness (Pope Leo X) has placed a great burden on my shoulders. He has put me in charge of the Fabric of St Peter's. I hope to be equal to the task, even more so since my design has pleased His Holiness and has been praised by many

fine intellects. But I would like to fly higher. I would like to re-create the beautiful forms of ancient buildings, but I do not know if I shall meet the same fate as Icarus."

(Letter to Baldassare Castiglione, circa 1514)

"Having closely studied these antiquities and having painstakingly examined them in detail and diligently assessed them, and constantly read the works of fine authors and applied their writings to my work, I think I have created something new out of that ancient architecture. On the one hand, this gives me the greatest pleasure for having learned such excellent things, and on the other the greatest pain, to see the almost dying soul of this noble city, which has been the queen of the world, so sadly ruined. Hence, if each man must show sympathy for his relatives and fatherland, I feel obliged to use all my humble strength, in order that a little of the image, indeed almost the shadow of the fatherland remain alive, which in effect is the universal home of all Christians."

(Letter to Pope Leo X, 1515)

A painter's sonnets

While he was working on the Disputation concerning the Blessed Sacrament *in the* Stanza della Segnatura, *Raphael became infatuated with a young woman whose name we do not know, writing for her some very sensual sonnets on the paper he was using for the preparatory drawings of the fresco. The following is the most meaningful.*

"Love, I was captivated by the light/of your beautiful eyes in which I languish, by your face,/ snow white and rosy pink,/ by your feminine charms./I burn so ardently, that neither sea nor rivers/can quench my fire,/but I mind not,/ since my ardor is so good for me,/that burning more each hour I am consumed by ardor/How sweet the yoke and chains/of your chaste kisses on my neck,/the more familiar they became the more I felt mortal pain./I shall say no more,/since supreme sweetness leads to death,/hence I shall remain silent and send my thoughts, that are many, winging to you."

HIS LIFE IN BRIEF

1483. Raphael Sanzio is born in Urbino on Good Friday, 6 April. His father is the painter Giovanni Santi and his mother Magia di Giovanbattista Ciarla.

1491. His mother dies. But he was already studying in the workshop of Perugino, to whom his father had introduced him.

1494. Raphael's father dies. The only surviving heir, he inherits the property of his grandparents on his mother's side.

1500. He receives his first commission from the Abbess of the Poor Clares of Monteluce in Perugia for a *Coronation of the Virgin* that was never executed.

1504. Probably visits Florence, Venice and Rome. Before painting the *Betrothal of the Virgin*, he studies Bramante's design for the Tempietto of San Pietro in Montorio in Rome. He goes to Florence with a letter of introduction from Giovanna Felicita Feltria della Rovere to the Gonfalonier of the Republic Pier Soderini Raffaello.

1507. The date of *The Deposition* in the Galleria Borghese in Rome.

1508. He is summoned by Pope Julius II to decorate the papal apartments in the Vatican.

1509. Pope Julius appoints him *scriptor brevium apostolicorum*, a prestigious office formerly held by Leon Battista Alberti. He works on the Stanza della Segnatura.

1511. He frescoes the Loggia overlooking the Tiber for Agostino Chigi's Roman Villa. It was destroyed during a flood.

1512. Raphael begins work on the Stanza di Eliodoro. He designs the Chigi Stables in Via della Lungara in Roma, which were demolished at the beginning of the nineteenth century; and builds the Chigi Chapel in Santa Maria del Popolo in Rome.

1514. Raphael succeeds Bramante, who dies in March, as Head of the Fabric of St Peter's, and is appointed *magister operis*. He begins the Stanza dell'Incendio, and buys a house in the Borgo district in Roma. He probably also spent time in Florence for the competition for the façade of San Lorenzo.

1516. He draws the cartoons for the tapestries in the Sistine Chapel.

1518. Raphael begins the Stanza di Costantino, but has to interrupt the work because of other commissions. He works on *The Archangel Michael Vanquishes Satan*, commissioned by the Pope's nephew Lorenzo de' Medici, for Francis I, King of France.

1519. He designs Villa Madama for Giulio de' Medici, in the Monte Mario district of Rome.

1520. After a brief illness, Raphael dies on Good Friday, 6 April, the same day on which he was born in 1483. He is buried in the Pantheon in Rome.

WHERE TO SEE RAPHAEL

The following is a listing of the technical data for the principal works of Raphael that are conserved in public collections. The list of works follows the alphabetical order of the cities in which they are found. The data contain the following elements: title, dating, technique and support, size expressed in centimeters.

DRESDEN (GERMANY)

St Francis, 1504; oil on wood, 26x87; Gemäldegalerie.

Sistine Madonna, 1515; oil on canvas, 265x196; Gemäldegalerie.

FLORENCE (ITALY)

Last Supper, 1495; fresco, 435x794; former Monastery of Sant'Onofrio.

Portrait of Perugino, 1495-96; oil on canvas, 59x46; Galleria degli Uffizi.

Portrait of Elisabetta Gonzaga, 1504-05; oil on wood, 58x36; Galleria degli Uffizi.

Portrait of Guidobaldo da Montefeltro, 1506; oil on canvas, 69x52; Galleria degli Uffizi.

Pope Julius II, 1512; oil on wood, 107x80; Galleria degli Uffizi.

Madonna of the Goldfinch, 1506; oil on wood, 107x77; Galleria degli Uffizi.

Virgin of the Canopy (Dei Altarpiece), 1507-08; oil on wood, 276x224; Palazzo Pitti.

Sacra Conversazione (Madonna dell'impannata), 1513; olio on panel, 158x125; Palazzo Pitti.

Portrait of Cardinal Bibbiena, 1516; olio on canvas, 86x65; Palazzo Pitti.

Pope Leo X with Cardinals Giulio de' Medici and Luigi de' Rossi, 1518-19; oil on wood, 154x119; Palazzo Pitti.

Madonna and Child (known as the Madonna del Granduca) 1506; oil on wood, 84x55; Palazzo Pitti.

Portrait of Agnolo Doni, 1506-07; oil on wood, 63x45; Palazzo Pitti.

Portrait of Maddalena Doni, 1506-07; oil on wood, 63x45; Palazzo Pitti.

Madonna of the Chair (known as the Madonna della Seggiola) 1513; oil on wood, diameter 71; Palazzo Pitti.

Portrait of a Woman (known as La Velata), 1516; olio on panel, 65x64; Palazzo Pitti.

LONDON (U.K.)

Flagellation, 1504-05; oil on wood, 56x48; National Gallery.

The Knight's Dream, 1504-05; oil on wood, 17x17; National Gallery.

St Catherine of Alexandria, 1508; oil on wood, 71x53; National Gallery.

Mond Crucifixion, 1503;
oil on wood, 279x166;
National Gallery.

Pope Julius II, 1512;
oil on canvas, 110x80;
National Gallery.

MILAN (ITALY)
Betrothal of the Holy Virgin, 1504;
oil on wood, 170x117;
Pinacoteca di Brera.

PARIS (FRANCE)
St Michael and the Dragon, 1505;
oil on wood, 31x27; Louvre.

St George and the Dragon, 1505;
oil on wood, 31x27; Louvre.

**Virgin and Child with
St John the Baptist
(known as La bella Giardiniera),**
1508; oil on wood, 122x80;
Louvre.

Portrait of Baldassarre Castiglione,
1515; oil on canvas, 82x67; Louvre.

Double Portrait, 1512; oil on canvas,
99x83; Louvre.

ROME (ITALY)
Stanza della Segnatura, 1508
School of Athens, fresco, base 770;
*Disputation concerning
the Blessed Sacrament,*
fresco, base 770;
Parnassus; fresco, base 670;
*Pope Gregory IX approving
the Decretals;* fresco, base 220;
Justinian with the Pandects;
fresco, base 220;
Vatican Apartments.

Stanza di Eliodoro, 1512
*Expulsion of Heliodorus
from the Temple;* fresco, base 750;

Miracle of the Mass at Bolsena;
fresco, base 660;
Liberation of St Peter; fresco, base 660;
*Encounter between Attila and Leo the
Great;* fresco, base 750;
Vatican Apartments.

Stanza dell'Incendio, 1514
Fire in the Borgo;
fresco, base 670;
*Leo IV's Naval Victory over
the Saracens at Ostia;*
fresco, base 770;
Coronation of Charlemagne;
fresco, base 770;
Investiture of Leo III;
fresco, base 670;
Vatican Apartments

**The Deposition
(known as the Baglioni Altarpiece),**
1508; oil on wood, 184x176; Galleria
Borghese.

Theological Virtues, 1507; oil on wood,
three sections 16x44;
Pinacoteca Vaticana.

Transfiguration, 1518-20;
oil on wood, 405x278;
Pinacoteca Vaticana.

**Coronation of the Virgin,
(known as the Oddi Altarpiece)**
1502-03; oil on canvas,
267x163; Pinacoteca Vaticana.

Triumph of Galatea, 1509; fresco,
295x225; Villa Farnesina.

Lady with a Unicorn, 1505-06; oil on
wood, 65x51; Galleria Borghese.

VIENNA (AUSTRIA)
**Virgin and Child with St John
the Baptist (known as the Madonna
del Prato),** 1506; oil on wood, 113x88;
Kunsthistorisches Museum.

BIBLIOGRAPHY

The bibliography on Raphael is endless. The *Vita
di Raffaello* in the *Vite* by Giorgio Vasari, II edition,
Florence 1568, republished in Florence in 1976
and edited by R. Bettarini and P. Barocchi (vol.
IV), is essential reading; likewise, *Raffaello. Gli
scritti, lettere, firme, sonetti, saggi tecnici e teorici,*
edited by E. Camesasca, Milan 1994.

1956 E. Camesasca, *Tutta la pittura di Raf-
faello. 1. I quadri. 2. Gli affreschi,* Mi-
lano

1963 W. Kelber, *Raphael von Urbino. 1. Leben
und Jugendwerke. 2. Die römischen Werke,*
Stuttgart

1966 P. L. De Vecchi, *L'opera completa di
Raffaello,* Milano

1969 R. Cocke, *The complete Painting of
Raphael,* London

1981 P. L. De Vecchi, *Raffaello: la pittura,*
Milano

1982 K. Oberhuber, *Raffaello,* Milano
A. Petrioli Tofani, P. L. De Vecchi, *I dis-
egni di Raffaello nel Gabinetto dei dis-
egni e delle stampe degli Uffizi,* cata-
logue of the Florence exhibition, Mi-
lano
C. Pedretti, *Raffaello,* Bologna

1983 R. Jones, N. Pennym, *Raphael,* New-
Haven, London
J. P. Cuzin, *Raphaël. Vie et oeuvre,*
Paris
P. Joannides, *The Drawings of
Raphael with a Complete Cata-
logue,* Oxford

1984 Var. auth., *Raffaello, elementi di un
mito. Le fonti, la letteratura artistica,
la pittura di genere storico,* Florence.
Var. Auth., *Raffaello architetto,* cata-
logue of the exhibition at the Musei
Capitolini, Roma

1985 G. Morello, *Raffaello e la Roma dei
papi,* catalogue of the Vatican exhi-
bition, Roma

1987 L. D. Ettlinger, H. S. Ettlinger, *Raphael,*
Oxford
Studi su Raffaello, Minutes of the Con-
vegno Internazionale Urbino-Firenze

1989 S. Ferino Pagden, M. Zancan, *Raf-
faello,* complete catalogue of paint-
ings, Firenze.

1990 *Raffael und die Zeichenkunst der Ital-
ienischen Renaissance,* catalogue of
the Cologne exhibition.

1992 D. Cordellier, B. Py, *Raffaello e i suoi,*
catalogue of the Villa Medici exhi-
bition, Rome.

1993 Var. auth., *Raffaello nell'appartamen-
to di Giulio II e di Leone X,* Milan.

1997 Giovanni Reale, *Raffaello e la Scuola
di Atene,* Milan.

Chagall
The Falling Angel

Dali
The Persistence of Memory

Kandinsky
The First Abstract Watercolour Painting

Leonardo
The Last Supper

Manet
Le déjeuner sur l'herbe

ONE HUNDRED PAINTINGS:

every one a masterpiece

The Work of Art. Which one would it be?

...It is of the works that everyone of you has in mind that I will speak of in "One Hundred Paintings". Together we will analyse the works with regard to the history, the technique, and the hidden aspects in order to discover all that is required to create a particular painting and to produce an artist in general.

It is a way of coming to understand the sensibility and personality of the creator and the tastes, inclinations and symbolisms of the age. The task of "One Hundred Paintings" will therefore be to uncover, together with you, these meanings, to resurrect them from oblivion or to decipher them if they are not immediately perceivable. A painting by Raffaello and one by Picasso have different codes of reading determined not only by the personality of each of the two artists but also the belonging to a different society that have left their unmistakable mark on the work of art. Both paintings impact our senses with force. Our eyes are blinded by the light, by the colour, by the beauty of style, by the glancing look of a character or by the serenity of all of this as a whole. The mind asks itself about the motivations that have led to the works' execution and it tries to grasp all the meanings or messages that the work of art contains.

"One Hundred Paintings" will become your personal collection. From every painting that we analyse you will discover aspects that you had ignored but that instead complete to make the work of art a masterpiece.

Federico Zeri

Coming next in the series:

Matisse, Magritte, Titian, Degas, Vermeer, Schiele, Klimt, Poussin, Botticelli, Fussli, Munch, Bocklin, Pontormo, Modigliani, Toulouse-Lautrec, Bosch, Watteau, Arcimboldi, Cezanne, Redon

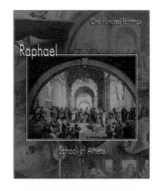

Raphael
School of Athens

Rembrandt
Supper at Emmaus

Renoir
Moulin de la Galette

Rubens
Garden of Love

Van Gogh
Starry Night